IMAGES
of America

SPARROWS POINT

D1501320

IMAGES
of America

SPARROWS POINT

Gary Helton

ARCADIA
PUBLISHING

Published by Arcadia Publishing
Charleston SC, Chicago IL, Portsmouth NH, San Francisco CA

Printed in the United States of America

Library of Congress Catalog Card Number: 2007922281

For all general information contact Arcadia Publishing at:
Telephone 843-853-2070
Fax 843-853-0044
E-mail sales@arcadiapublishing.com
For customer service and orders:
Toll-Free 1-888-313-2665

Visit us on the Internet at www.arcadiapublishing.com

CONTENTS

ACKNOWLEDGMENTS

I sincerely wish to thank everyone who encouraged and supported this project. Jeff Korman and the staff of the Maryland Department at the Enoch Pratt Free Library in Baltimore were of tremendous help, as they were with my previous book, Images of America: *Highlandtown*. I also deeply thank Jean Walker and her staff at the Dundalk–Patapsco Neck Historical Society Museum for all their help, especially Lil Tirschman, who oversees the files on Sparrows Point. And a big thank-you goes out to Cecelia Lesser, the curator at the Sparrows Point High School Heritage Center. Their extensive, well-organized collection of school and town artifacts is a history buff's dream come true. Many individuals provided photographs and information, including Joe Sock, Betty Lane, and Frank and Marcee Zakwieia, for which I am also very grateful. Thanks also go to my son Jason Helton for coming to my rescue during a last-minute software glitch and to my ever-tolerant wife, Mary Ellen, who wants to know when I'm putting my mess away. We were to be married at the old St. Luke's Church in Sparrows Point in 1975, but the bulldozers beat us to it.

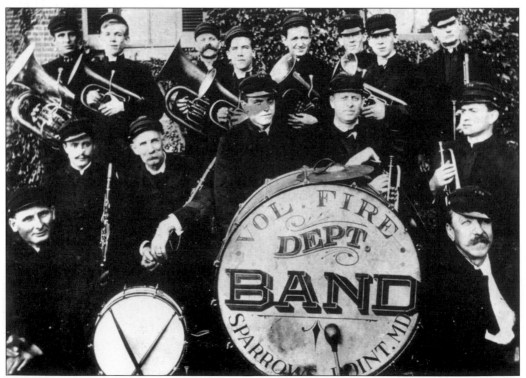

The Sparrows Point Volunteer Fire Department Band posed for this group shot in 1912. (Courtesy Dundalk–Patapsco Neck Historical Society Museum.)

INTRODUCTION

According to archaeologists, the area that would come to be known as Sparrows Point had been occupied for more than 8,000 years by the time it was parceled out to settlers by Cecil Calvert, the second Lord Baltimore. So it isn't fair to say that the area wasn't discovered, explored, or settled before 1652. Beneficiaries of Calvert's proprietary land grants included one Thomas Sparrow Jr., a resident of Anne Arundel County. Sparrow came to own 1,000 acres of woody, swampy terrain north of the Patapsco River, though he never lived there and may have never even set foot on the property. It was his son, Solomon Sparrow, who is believed to have established the first residence on the peninsula during the 1660s or 1670s, calling it "Sparrow's Nest." However, researchers have never been able to establish with any certainty whether Solomon or any member of the Sparrow family ever lived there. One record shows that a John Rous(e) occupied the tract in the early 1700s. In any case, the land seems to have passed from the Sparrow family with the death of Solomon Sparrow in 1718.

In the 169 years that followed, families named Todd, Jones, Gorsuch, and others worked the rich soil. They harvested the region's timber, raised livestock, and encountered great success growing a variety of fruits, vegetables, and grain. Abundant wildlife and waterfowl attracted early sportsmen, who constructed hunting lodges. A new breed of sporting dog dubbed the Chesapeake Bay retriever was first bred here in the early 1800s. And the bounty of the nearby bay, the Patapsco River, and their tributaries contributed greatly to the region's prosperity and virtual self-sufficiency.

Sometime around 1860, Sparrow's Nest began being referred to as "Sparrows Point," and William H. Albert, who had been operating one of the area's waterfront hunting lodges, acquired the former Sparrow's Nest property. Following his death, Albert's son Lowry sold 385 acres to one Capt. and Mrs. William Fitzell, who turned it into a peach orchard.

Unbeknownst to the Fitzells, around 1886, officials of the Pennsylvania Steel Company began searching for a new tidewater site. Headquartered near Harrisburg along the Susquehanna River in the town of Steelton, such a site, officials reasoned, would give them the means to import raw materials, produce steel, and thereafter distribute it to domestic and foreign markets without the time and expense of overland transportation. Sites along the Chesapeake Bay, Delaware Bay, and the Delaware River were considered. Ultimately the company chose Sparrows Point and sent a representative, Jacob Taylor, to purchase 1,221 acres on their behalf. Nearly 400 of those acres were the property of Captain and Mrs. Fitzell, who were perfectly happy raising peaches on the northern banks of the Patapsco. While it took some persuading, Fitzell eventually agreed to sell, and by the summer of 1887, the foundation for a blast furnace had been constructed in the former peach orchard. Pennsylvania Steel created a new subsidiary, the Maryland Steel Company, and assigned planners and laborers to drain wetlands, lay out a company town for its future workforce, and construct what would one day be the largest steel plant in the world. Homes, schools, and churches were hastily constructed. A transportation system was set up—first by water, then by rail. "Furnace A" came online in October 1889. Two years later, a shipyard was under construction. As the plant quickly grew, so did its workforce, many of whom elected to live in the company town, along streets designated by letters or numbers. Which street you lived on was determined by the

7

importance of your job and the color of your skin. Meanwhile, by the early 20th century, United Electric Railways of Baltimore extended their streetcar lines, making it possible for workers to commute to and from neighborhoods like Highlandtown and East Baltimore, where large pockets of immigrants and African Americans had already set up housekeeping.

In 1916, the Bethlehem Steel Corporation acquired Sparrows Point and soon came to be known as "Mother Bethlehem" to many. After all, it provided a trade and a paycheck, plus a self-sufficient community that offered residents educational, spiritual, and recreational opportunities. Sparrows Point also had its own police and fire departments, a dairy, community center, company stores, sewage treatment plant, and a railroad station. There was Pennwood Park for baseball and football, a public beach, banks, a post office, and the Lyceum Theatre with its eight duckpin lanes in the basement. Other retailers set up shop along D Street in buildings rented to them by Bethlehem. In many respects, Sparrows Point emerged as a model company town. It did, however, have myriad shortcomings that reflected the technology, laws, and customs of its time. Segregated employment opportunities, housing, and public facilities and little or no regard for the environment were major deterrents to life at "the Point." Notwithstanding, by 1959, Bethlehem Steel's Sparrows Point plant employed more than 33,000 people. About this same time, bits and pieces of the company town began to disappear for plant expansion—a process that slowly continued until 1974, when the last house in Sparrows Point was bulldozed. Bethlehem Steel itself would disappear in 2003.

The objective of this publication is not to pontificate or sit in judgment on corporate operations or ethics, labor unions, environmental concerns, race relations, foreign steel tariffs, and the like. It is simply to revisit through photographs a prosperous time for American industry and a way of life for three generations of "Pointers."

One

From Peaches to Pig Iron

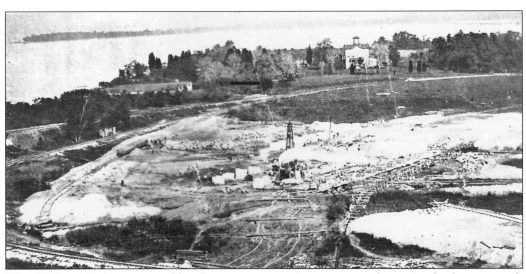

This 1887 aerial view captures blast furnace construction getting underway in the former peach orchards of Capt. and Mrs. William Fitzell, the last private landowners of Sparrows Point. Pennsylvania Steel purchased the Fitzell property because of its deepwater access and proximity to rail lines, factors that would facilitate the transport of ore and finished products to and from their Steelton, Pennsylvania, plant. (Courtesy Dundalk–Patapsco Neck Historical Society Museum.)

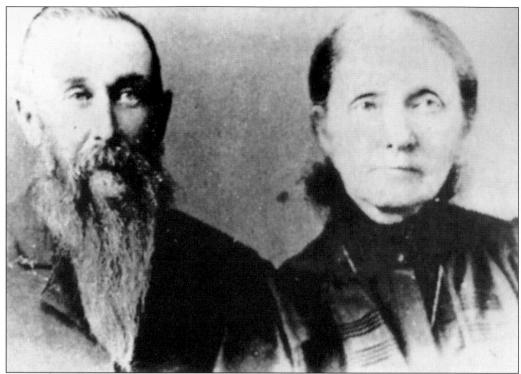

Capt. and Mrs. William Fitzell are seen in this image from the late 19th century. As part of the real estate transaction, Pennsylvania Steel Company built the Fitzells a duplicate of their Sparrows Point home a few miles up the road in Edgemere. (Courtesy Dundalk–Patapsco Neck Historical Society Museum.)

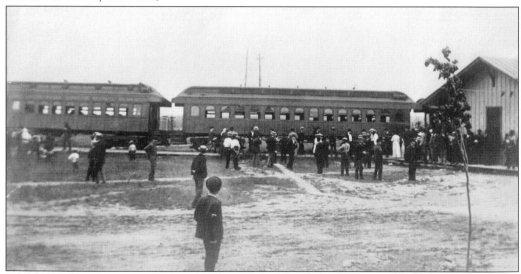

The Baltimore and Sparrows Point Railroad followed Colgate Creek for five miles and connected Sparrows Point to the Baltimore and Ohio and Pennsylvania Railroads' mainlines. Passenger train service began in February 1889. In so doing, it replaced boats as the primary source of transport between Sparrows Point and Baltimore. This photograph at the Sparrows Point depot was taken around 1900. (Courtesy Dundalk–Patapsco Neck Historical Society Museum.)

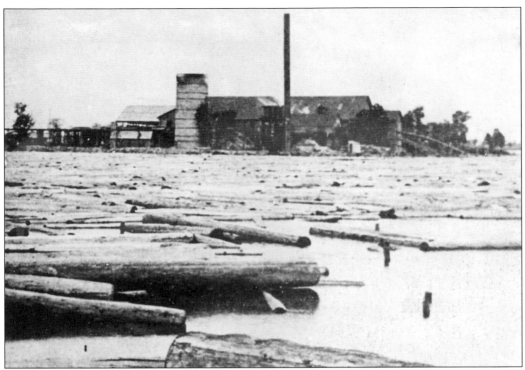

Lumber was essential to the early construction needs of Sparrows Point—especially for housing and the rail link to Baltimore. One of the first operations to set up shop was the Chesapeake Saw Mill, on Humphrey's Creek. This photograph was taken in the 1890s. (Courtesy Dundalk–Patapsco Neck Historical Society Museum.)

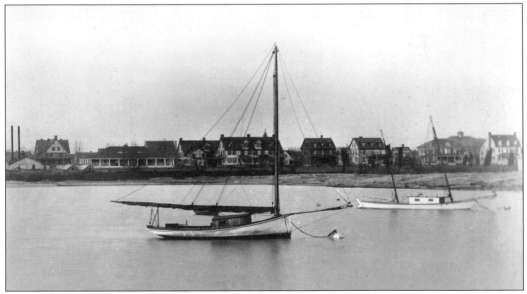

Skipjacks and bugeyes were commonly seen in the waters around Sparrows Point, harvesting crabs, oysters, and fish in abundance. B Street can be seen in the background of this photograph, taken November 21, 1903. This area was eventually filled in by Bethlehem Steel and became a parking lot. (Courtesy Barker Collection, Maryland Department, Enoch Pratt Free Library.)

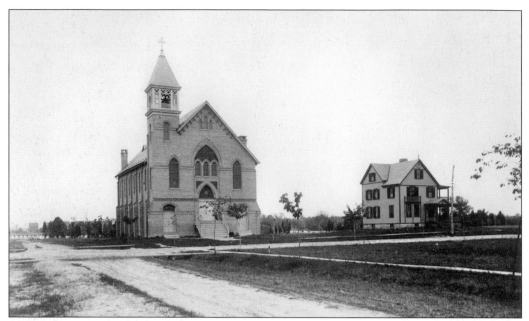

St. Luke's Roman Catholic Church was established in 1888 and was located at Sixth and D Streets. Sparrows Point's streets were unpaved when this photograph of the church and rectory was taken around 1890. (Courtesy Dundalk–Patapsco Neck Historical Society Museum.)

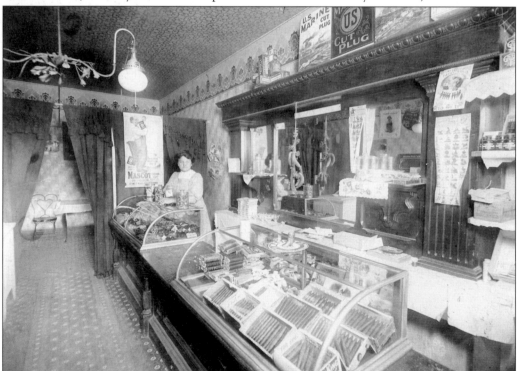

Marian Rumph Zang operated a confectionary shop at the Point that featured ice cream, tobacco products, candy, and more. She posed behind the counter for this photograph in 1913. (Courtesy Dundalk–Patapsco Neck Historical Society Museum.)

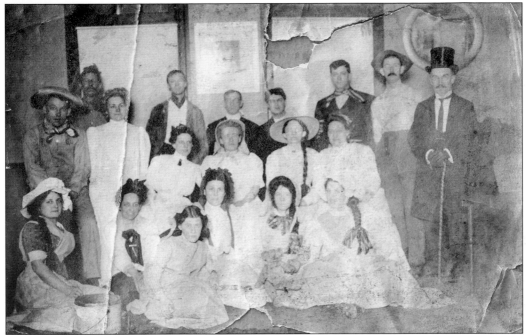

Some of the early entertainment in Sparrows Point included acting troupes. Mr. Newlin's Orchestra is seen in this 1905 photograph. Their leader, H. Menton Newlin, is at the far right in the top hat. Other members of the group are unidentified. (Courtesy Dundalk–Patapsco Neck Historical Society Museum.)

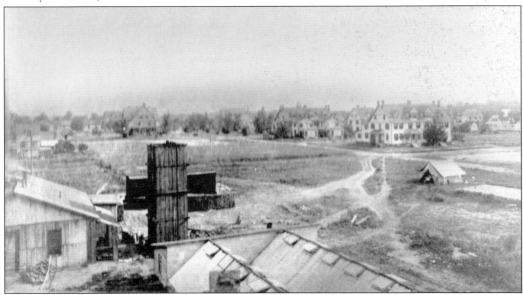

B Street can be seen in this 1909 photograph taken from atop a blast furnace. Housing in Sparrows Point was assigned based on position and race. The general manager lived on A Street. Homes on B, C, and D Streets rented to supervisors and foremen, and so on. African Americans were at the bottom of the Sparrows Point pecking order, isolated across Humphrey's Creek on I and J Streets, an area referred to as the North Side. (Courtesy Dundalk–Patapsco Neck Historical Society Museum.)

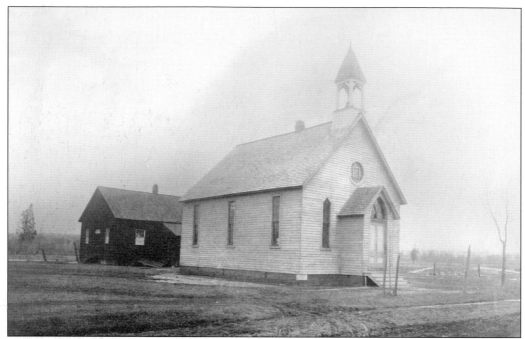

The Union Baptist Church was organized in the 1890s at Eighth and J Streets, serving the African American community. (Courtesy Dundalk–Patapsco Neck Historical Society Museum.)

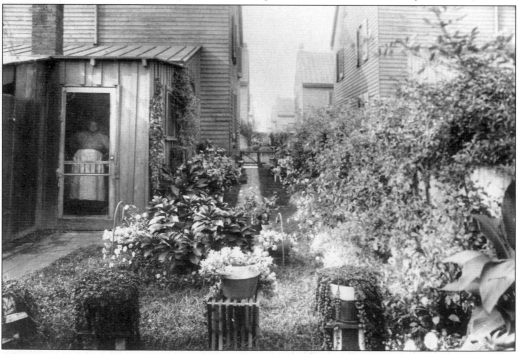

Pennsylvania Steel Company (and Maryland Steel, the subsidiary they eventually established to run Sparrows Point) was concerned about life in the company town and encouraged gardening and beautification projects. This resident of E Street took part in the annual gardening competition in 1914. (Courtesy Dundalk–Patapsco Neck Historical Society Museum.)

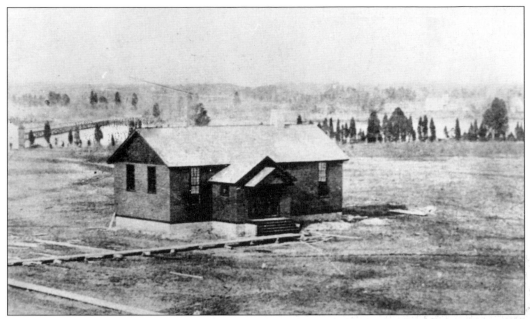

Another early priority of plant management was public education. The first school in Sparrows Point was established at Fourth and D Streets on April 16, 1888. This photograph was taken shortly afterward. (Courtesy Dundalk–Patapsco Neck Historical Society Museum.)

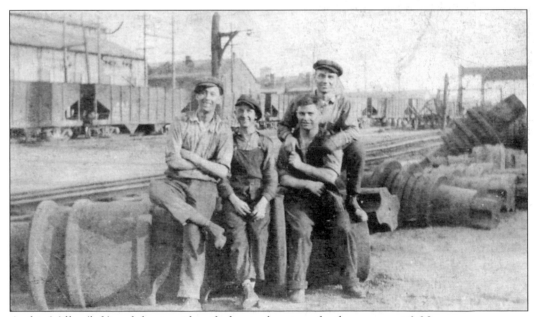

Archie Miller (left) and three unidentified coworkers mug for the camera at 6:00 a.m. one summer morning in June 1916. Miller and his wife, Marie, raised five children in an E Street row house, three of whom went on to work for Bethlehem Steel. (Courtesy Marcee Zakwieia.)

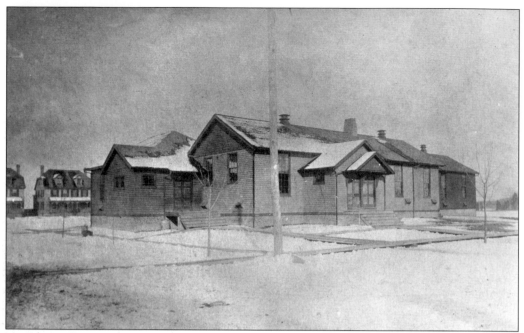

The Sparrows Point school is seen on this snowy day in 1890. George W. Ijams was the school's first principal but resigned in 1889 because of poor health. He was replaced by Joseph Blair, who served both Sparrows Point elementary and high schools for 42 years until his retirement in 1931. (Courtesy Sparrows Point High School Heritage Center.)

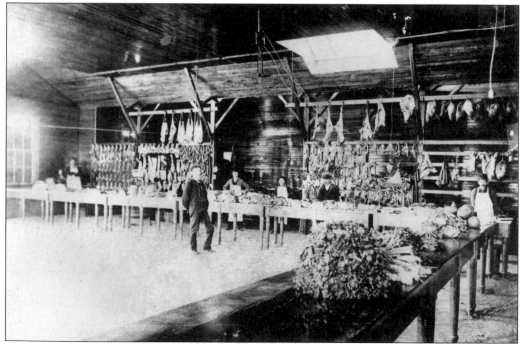

The Company Store at Sparrows Point offered just about everything anyone in town might need. This shot from the 1890s shows the meat and produce departments. (Courtesy Dundalk–Patapsco Neck Historical Society Museum.)

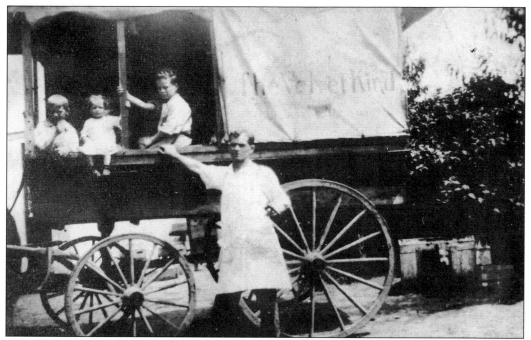

Long before the Good Humor man, vendors sold ice cream along the streets of Sparrows Point in horse-drawn wagons. The advertisement on the side of the wagon is for Hendler's ice cream, "The Velvet Kind." This photograph was taken around 1900. (Courtesy Sparrows Point High School Heritage Center.)

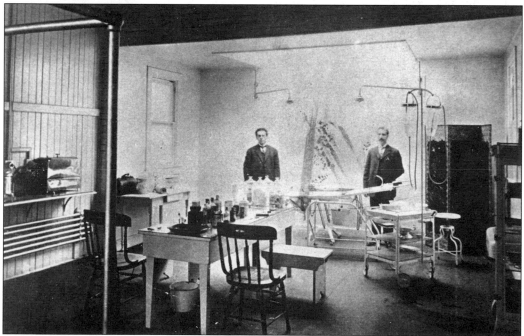

The Maryland Steel Company dispensary is visible in this 1910 photograph; the personnel are unidentified. Accidents and injuries were commonplace in the days before safety equipment and regulations. (Courtesy Dundalk–Patapsco Neck Historical Society Museum.)

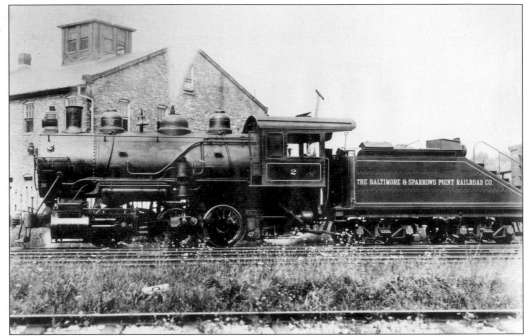

The Baltimore and Sparrows Point Railroad was established in 1889 to link Sparrows Point to Baltimore via the existing mainlines of the Baltimore and Ohio and the Pennsylvania Railroads. However, the need for passenger trains to and from the Point was eliminated by 1903, when streetcar service to and from Baltimore began. Engine and tender No. 2 are seen at work at Sparrows Point in this undated picture. (Courtesy Dundalk–Patapsco Neck Historical Society Museum.)

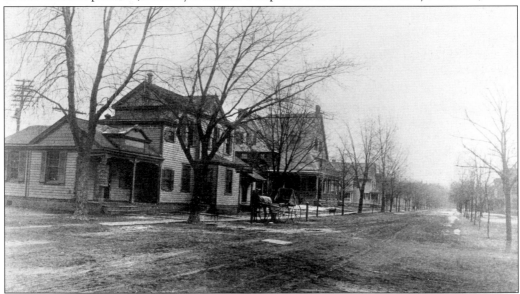

This image from around 1910 shows Fourth and C Streets. From left to right, the businesses in the foreground are Provident Bank, a real estate office, the telephone exchange, and the post office. The two large structures next door are the restaurant and the home of Dr. Frank Eldred, one of Sparrows Point's earliest physicians. (Courtesy Dundalk–Patapsco Neck Historical Society Museum.)

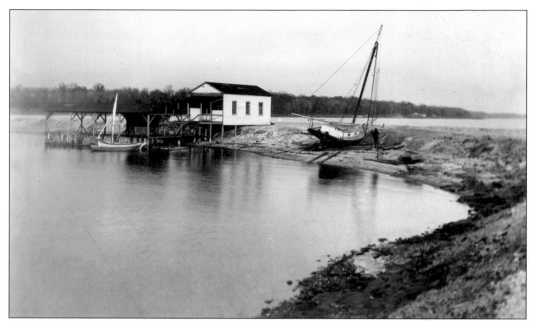

This photograph shows another area that was eventually filled in by Bethlehem Steel. A lone waterman can be seen to the right of the boathouse in this pristine setting captured for eternity on November 21, 1903. (Courtesy Barker Collection, Maryland Department, Enoch Pratt Free Library.)

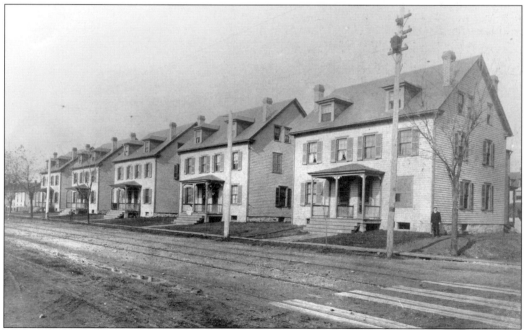

The streetcar tracks and overhead power lines of the United Electric Railways are visible in this picture of D Street taken around 1910. With the coming of streetcar service in 1903, scores of immigrant laborers from Highlandtown—then part of Baltimore County—made their way to jobs in Sparrows Point, necessitating the need for hiring personnel fluent in German, Russian, Italian, Polish, and other languages. (Courtesy Dundalk–Patapsco Neck Historical Society Museum.)

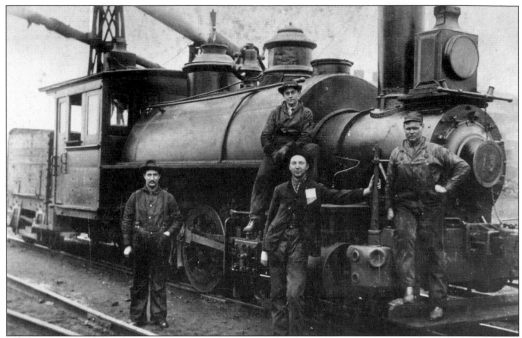

The unidentified crew of Engine No. 13 paused long enough to pose for the photographer in this shot taken around 1910. The importance of the railroad to Sparrow Point cannot be understated. In time, the plant's switcher line would be known as the Patapsco and Back Rivers Railroad. (Courtesy Dundalk–Patapsco Neck Historical Society Museum.)

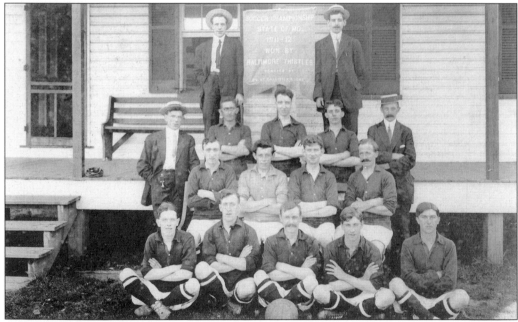

Sparrows Point's soccer team made it to the state championship game in 1912, losing to the Baltimore Thistles. Soccer, long popular in Europe, caught on quickly in Sparrows Point, Highlandtown, and other areas where immigrant populations were high. (Courtesy Dundalk–Patapsco Neck Historical Society Museum.)

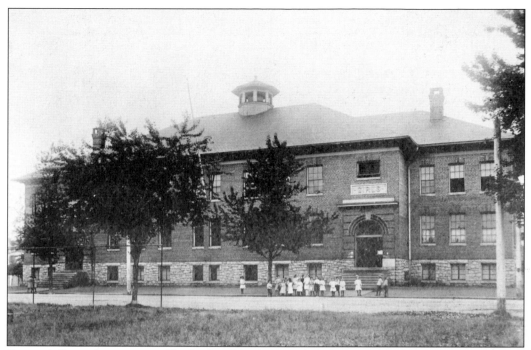

Sparrows Point elementary and high schools are seen in this photograph, taken sometime between 1911 and 1915. The high school moved to a new, separate facility in 1921. (Courtesy Sparrows Point High School Heritage Center.)

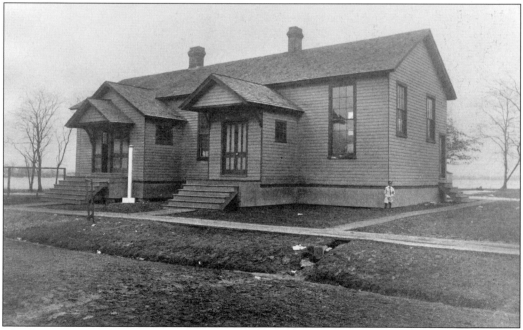

This building was known as the Elementary Colored School. Segregation by race in housing and education was the rule in 1915, when this photograph was taken. High school was unavailable to African American children in Sparrows Point until 1939, with the opening of the George F. Bragg High School. (Courtesy Sparrows Point High School Heritage Center.)

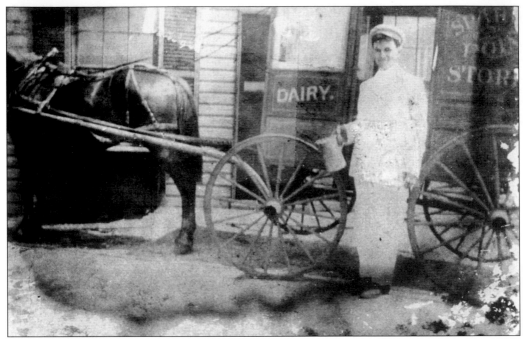

Wiley Machen lived in the 500 block of E Street and delivered milk in Sparrows Point. He is shown in this early-1900s photograph alongside his delivery wagon and horse. (Courtesy Dundalk–Patapsco Neck Historical Society Museum.)

A pair of unidentified men stands outside Bill Gambrill's Ice Cream Parlor and Pool Room, which was located at Fourth and D Streets. This photograph was taken in 1910. (Courtesy Dundalk–Patapsco Neck Historical Society Museum.)

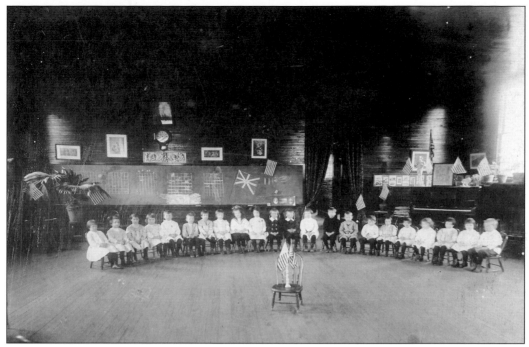

The first public kindergarten south of the Mason-Dixon line was established at Sparrows Point in September 1892. Rita M. Armstrong was its first instructor. The 1910 class is seen in this photograph. (Courtesy Sparrows Point High School Heritage Center.)

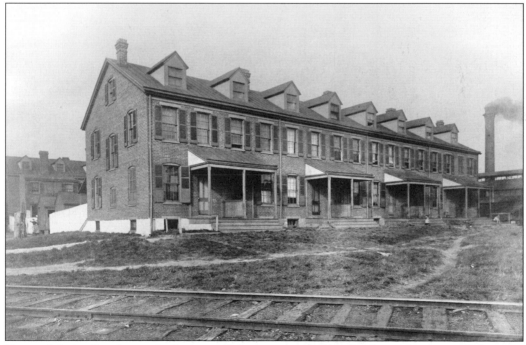

Some of the earliest homes in Sparrows Point were erected in the shipyard area, on Baltimore, Canton, Eutaw, and Dover Streets. This photograph dates to 1910. (Courtesy Dundalk–Patapsco Neck Historical Society Museum.)

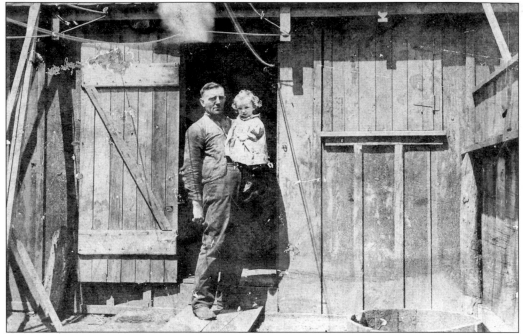

Laundry and outhouse facilities were in sheds in the rear of the shipyard houses. An unidentified man and child are seen in this shot from around 1900. (Courtesy Dundalk–Patapsco Neck Historical Society Museum.)

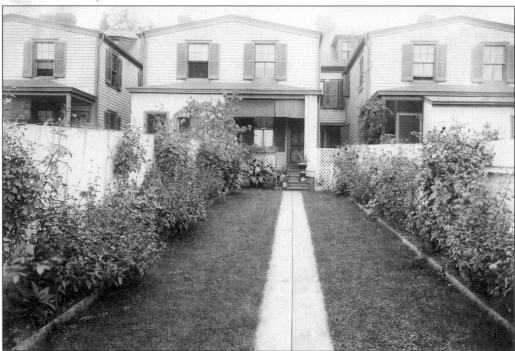

Boardwalks existed before sidewalks in Sparrows Point. The lovely grounds of this home, at 720 E Street, reflected the pride many residents took in their community in 1914. (Courtesy Dundalk–Patapsco Neck Historical Society Museum.)

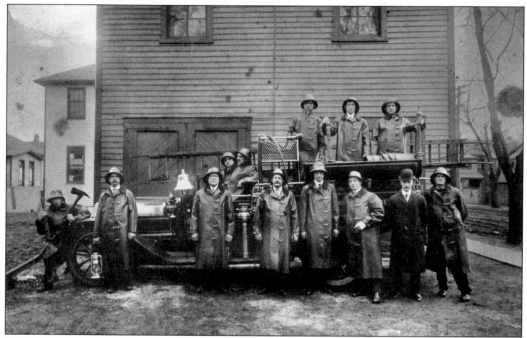

Members of the fire department seen in this 1915 photograph are, from left to right, (first row) Dump Lane, Percy Smith, John McFadden, Baze Miller, Herbert Mitchell, Sam Bull, Harry Merchant, and Al Oberly; (second row, seated in the cab) Chester Sniveley and Tom Long; (third row) Clarence Sniveley, Frank Oberly, and John Moor. (Courtesy Dundalk–Patapsco Neck Historical Society Museum.)

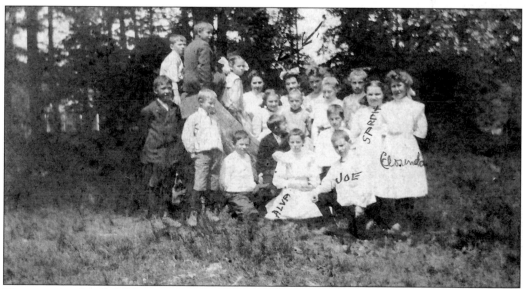

Elementary school children at play were photographed in 1909 or 1910 near North Point and Lodge Farm Roads. (Courtesy Sparrows Point High School Heritage Center.)

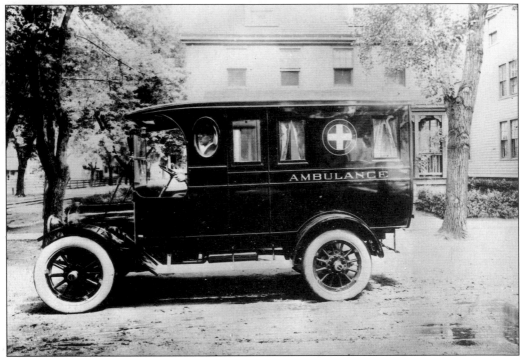

Sparrows Point's ambulance looked brand-new when this photograph was taken on July 14, 1916. The driver is unidentified. (Courtesy Dundalk–Patapsco Neck Historical Society Museum.)

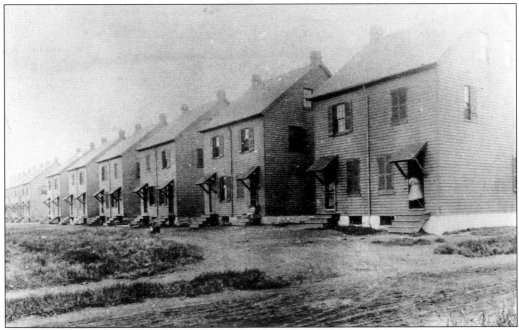

This early photograph of the North Side, taken around 1910, shows houses for African American employees on I Street. The North Side was accessed by a footbridge over Humphrey's Creek. Houses had no electricity and were heated in winter by coal stoves. They rented for around $5 a month. (Courtesy Dundalk–Patapsco Neck Historical Society Museum.)

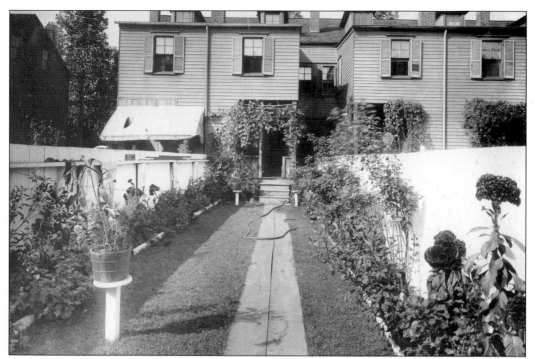

Another backyard garden was in full bloom when this photograph was shot at 419 East F Street in 1914. The company sponsored gardening competitions annually. (Courtesy Dundalk–Patapsco Neck Historical Society Museum.)

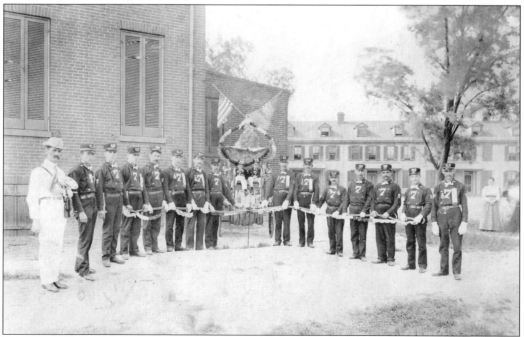

Members of the volunteer fire department at the shipyard pose for the photographer in 1910. There were two units: one at Fourth and D Streets and this group, Hose Company No. 7. (Courtesy Dundalk–Patapsco Neck Historical Society Museum.)

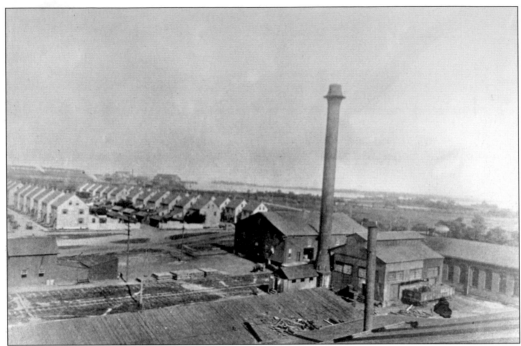

This 1904 photograph was taken in the west end of Sparrows Point, near the shipyard. The foundry and machine shop are visible in the foreground. (Courtesy Dundalk–Patapsco Neck Historical Society Museum.)

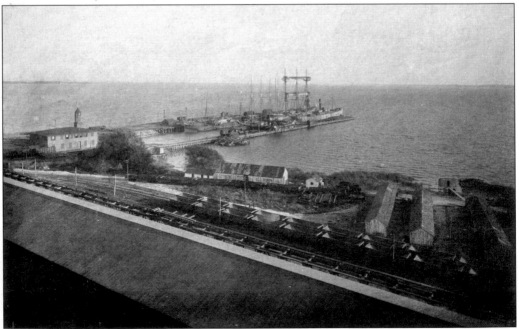

Both steam- and sail-powered ships can be seen in this early shot of the Sparrows Point ore piers, where the Patapsco River meets the Chesapeake Bay. Schooners from Maine were delivering ice when this photograph was taken in the 1890s. (Courtesy Sparrows Point High School Heritage Center.)

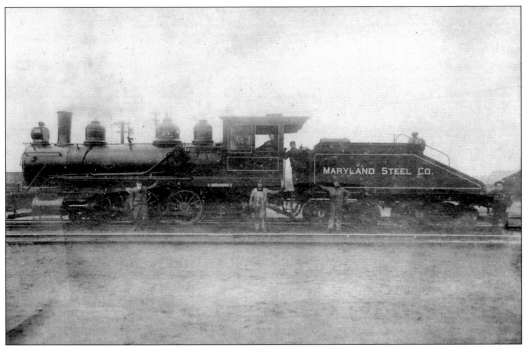

Engine No. 23 carries the name of Maryland Steel Company on its tender in this photograph from around 1910. This unit was one of many that shuttled resources into and finished products out of the plant. (Courtesy Dundalk–Patapsco Neck Historical Society Museum.)

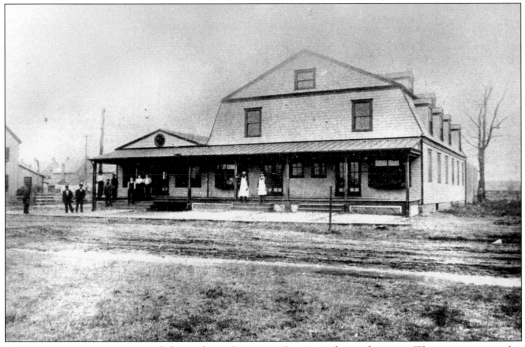

Company stores were situated throughout Sparrows Point in the early years. This one was in the North Side, Sparrows Point's residential area for African Americans. The photograph is from around 1900. (Courtesy Dundalk–Patapsco Neck Historical Society Museum.)

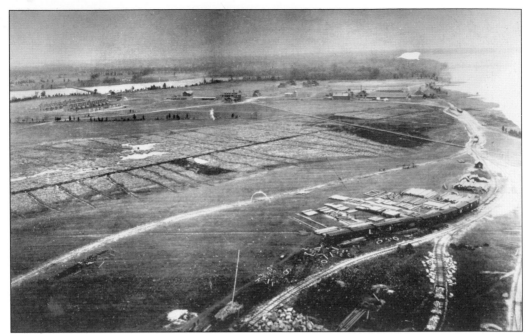

There was plenty of room to grow when this early-1900s photograph was taken. Pennsylvania Steel exercised exceptional foresight when they selected the Sparrows Point site in 1887, even though it was necessary to drain and fill in large tracts to make them suitable for industry and housing. Environmental protection laws today would make such actions illegal. (Courtesy Dundalk–Patapsco Neck Historical Society Museum.)

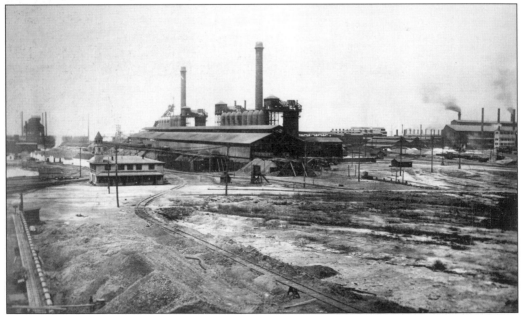

The Sparrows Point steelmaking operation was already 20 years old when this photograph was taken around 1910. Expansion took place at a breakneck pace in 1916, when Bethlehem Steel acquired the plant and shipyard. (Courtesy Baltimore Municipal Museum and the Maryland Department, Enoch Pratt Free Library.)

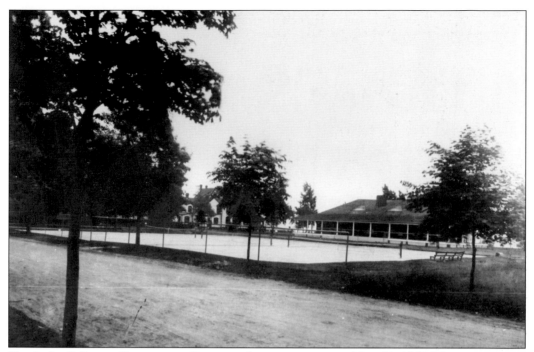

Here's the B Street Community Center and tennis courts on May 20, 1915. The community center was the site of events and activities until the 1950s. (Courtesy Dundalk–Patapsco Neck Historical Society Museum.)

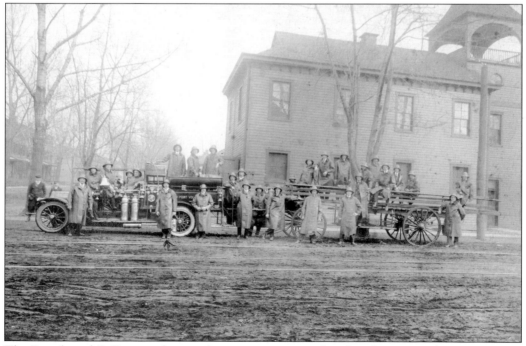

The Fourth and D Street volunteer firemen are seen in this shot from around 1910. A small arrow points to Percy B. Smith. The others are unidentified. (Courtesy Dundalk–Patapsco Neck Historical Society Museum.)

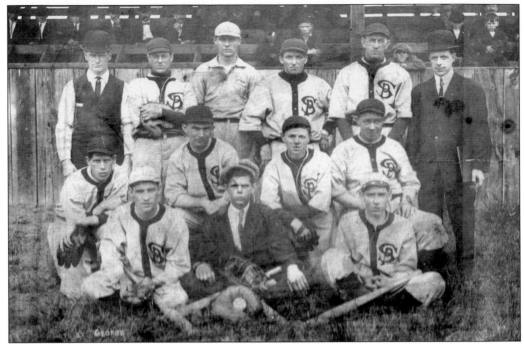

Team sports were actively promoted in Sparrows Point, and early baseball fields were situated near the Chesapeake Mill sawmill. This photograph was taken around 1910. The players are unidentified. (Courtesy Dundalk–Patapsco Neck Historical Society Museum.)

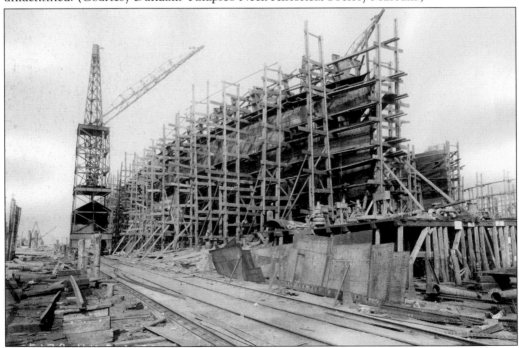

On August 24, 1915, the photographer set up his equipment in the Maryland Steel shipyard, where a pair of ships can be seen under construction within wooden scaffolding. (Courtesy Dundalk–Patapsco Neck Historical Society Museum.)

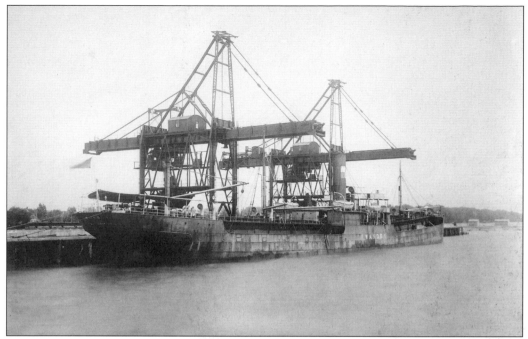

At the ore piers, the *Wandby* sits deep in the water ready to offload resources for the Sparrows Point steelmaking process in 1910. The Sparrows Point Bathing Beach was situated close by. (Courtesy Dundalk–Patapsco Neck Historical Society Museum.)

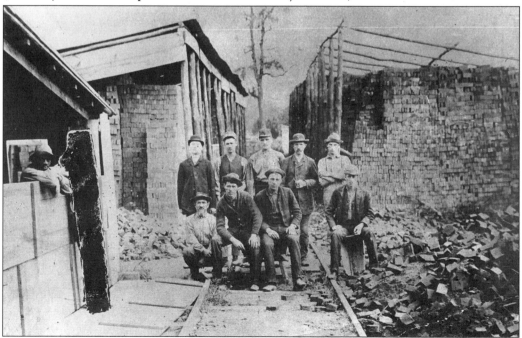

Along with the sawmill, a brickyard was one of the earliest facilities constructed at Sparrows Point. Large deposits of clay were found on the property, and the bricks it produced were used for many of the early buildings in Sparrows Point. This photograph is from around 1900. (Courtesy Sparrows Point High School Heritage Center.)

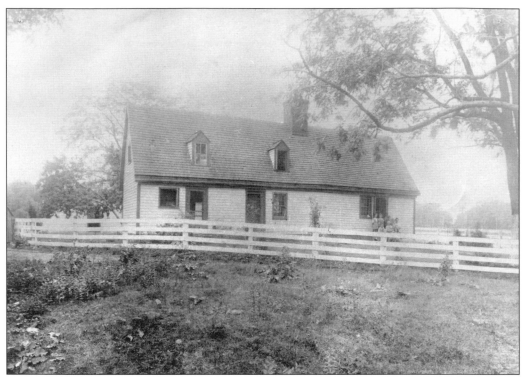

The Soller family's farmhouse was situated on the Soller's Point side of Humphrey's Creek. It's seen in this picture from around 1890. (Courtesy Sparrows Point High School Heritage Center.)

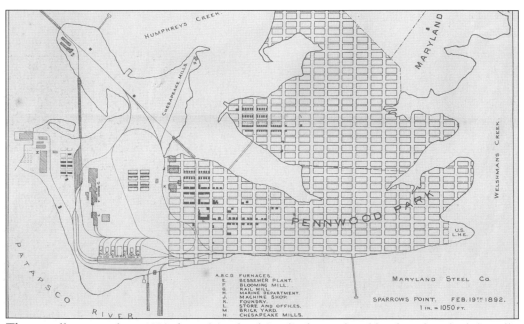

This excellent map from 1892 shows Maryland Steel's shipyard and brickyard at the left, mills, furnaces, and ore piers at the lower left, residences in the center, and Pennwood Park to the right. (Courtesy Sparrows Point High School Heritage Center.)

Two

MOTHER BETHLEHEM

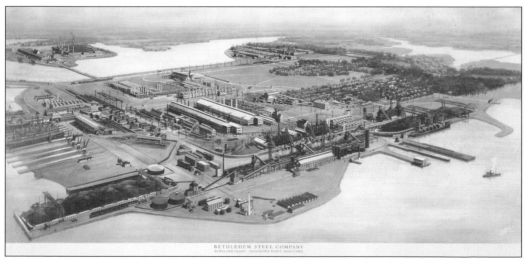

BETHLEHEM STEEL COMPANY
MARYLAND PLANT · SPARROWS POINT, MARYLAND

This aerial view is a drawing created in 1929. By this time, Bethlehem Steel had established the Dundalk Company, which constructed additional new housing and retail properties in the area that is now Dundalk Village Shopping Center. (Courtesy Maryland Department, Enoch Pratt Free Library.)

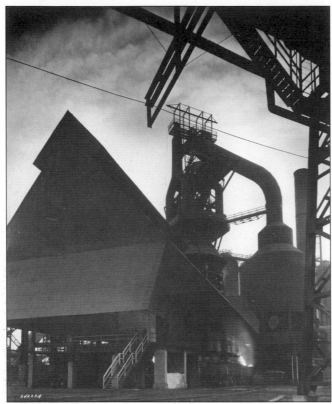

Here is Blast Furnace H, which began operation in April 1948. The postwar years were a period of unprecedented growth at Sparrows Point. This photograph was taken in March 1953. (Courtesy Maryland Department, Enoch Pratt Free Library.)

The main company store was getting ready to close when this photograph was snapped on September 11, 1944. As the plant expanded, it began to slowly consume the town. (Courtesy Dundalk–Patapsco Neck Historical Society Museum.)

Charles Cook managed the company store in the early 1900s. He left the job reportedly because of his upset over employee indebtedness. Apparently some received little or no money on payday because of all they owed the store. (Courtesy Dundalk–Patapsco Neck Historical Society Museum.)

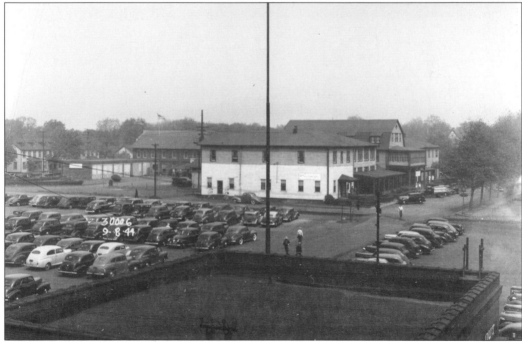

It was September 8, 1944, and the company store closeout sale attracted plenty of shoppers, as evidenced by all the parked cars. (Courtesy Dundalk–Patapsco Neck Historical Society Museum.)

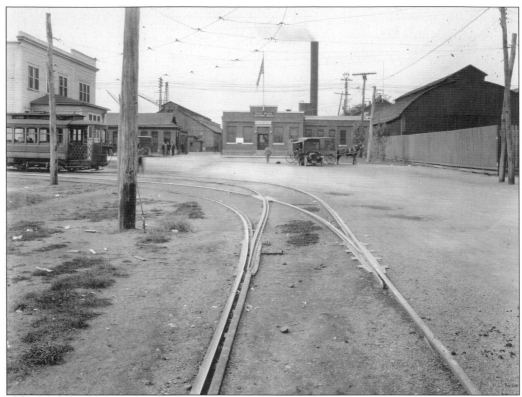

A streetcar waits at the shipyard loop, while a lone man walks to the employment office, passing a horse-drawn wagon and a lunch truck. This photograph is believed to be from 1916. (Courtesy Joe Sock.)

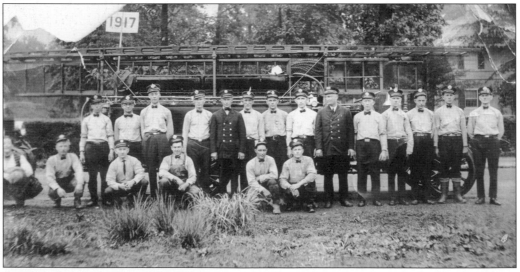

Sparrows Point's volunteer firefighters got together for another group photograph, this time during the summer of 1917. (Courtesy Betty Lane.)

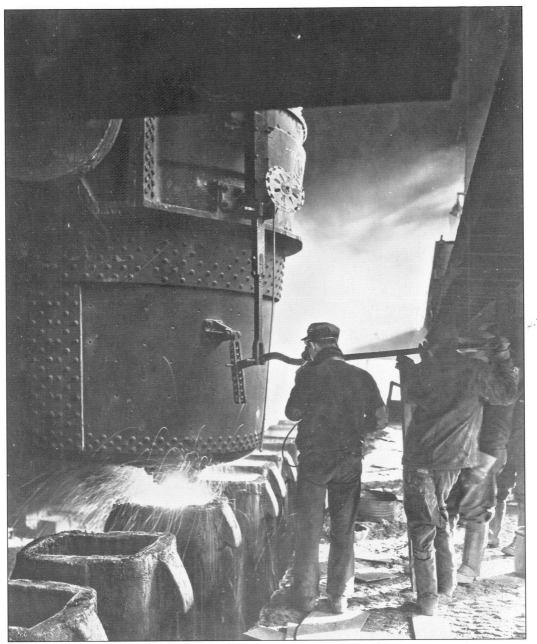

In this photograph from the 1930s, steel made in Sparrows Point's open-hearth furnaces is cast into molds to make ingots for subsequent rolling. (Courtesy Maryland Department, Enoch Pratt Free Library.)

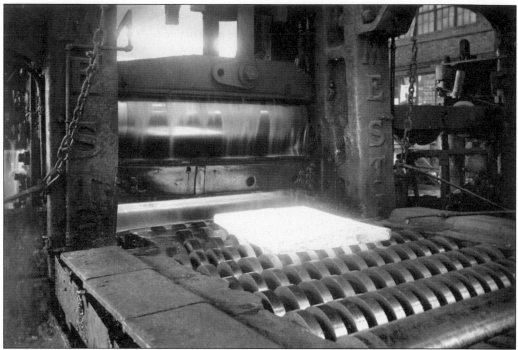

In a 1938 picture, the continuous skelp mill provides skelp for the pipe mills and semi-finished products. The process, like many at Sparrows Point, was hot and dangerous. Skelp is a piece or strip of metal produced to a certain thickness, width, and edge configuration used to make tubing or pipe. (Courtesy Maryland Department, Enoch Pratt Free Library.)

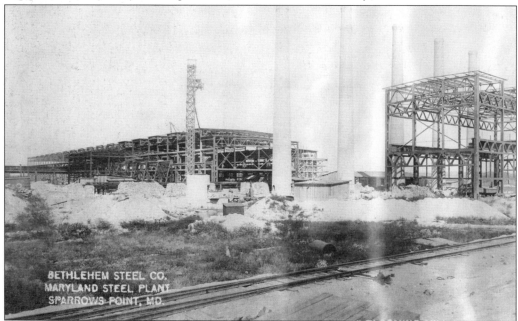

The blooming mill is under construction in this photograph from October 10, 1918. A blooming mill reduces ingots to blooms, billets, slabs, sheet-bar, and other semi-finished steel. (Courtesy Dundalk–Patapsco Neck Historical Society Museum.)

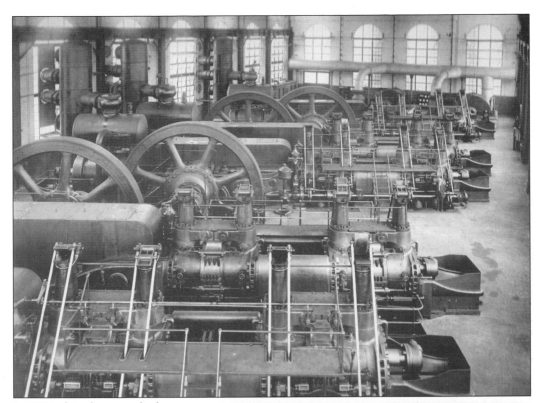

In 1938, this plant supplied one half of all electricity consumed at Sparrows Point. It used six generators driven by four-cylinder, twin-tandem gas engines. (Courtesy Maryland Department, Enoch Pratt Free Library.)

This 1938 shot shows one of the artesian wells at Sparrows Point. The wells supplied fresh water for drinking, boilers, and more. (Courtesy Maryland Department, Enoch Pratt Free Library.)

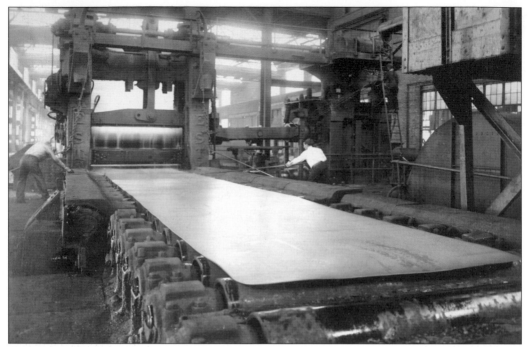

The 110-inch plate mill is the subject of this photograph, which was taken in 1934. With the exception of gloves, workers used little protective equipment. (Courtesy Maryland Department, Enoch Pratt Free Library.)

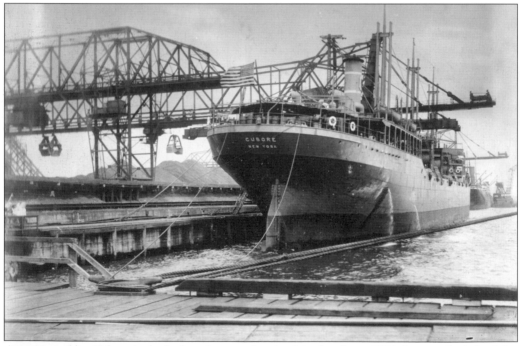

American ship *Cubore* is docked at the ore piers in this shot from 1934. Just to the left of the American flag, a crew member's laundry hangs out to dry on an improvised clothesline. (Courtesy Maryland Department, Enoch Pratt Free Library.)

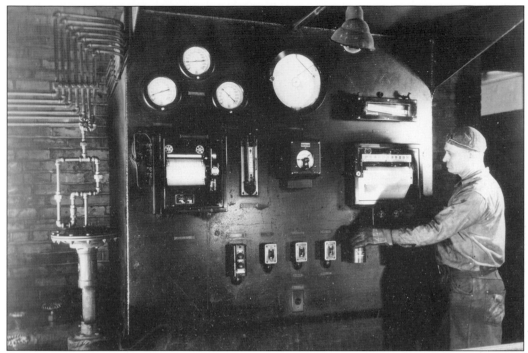

A worker in this photograph monitors instruments designed to closely ensure the metallurgical control of metal in the furnace. This shot was taken in the mid-1930s. (Courtesy Maryland Department, Enoch Pratt Free Library.)

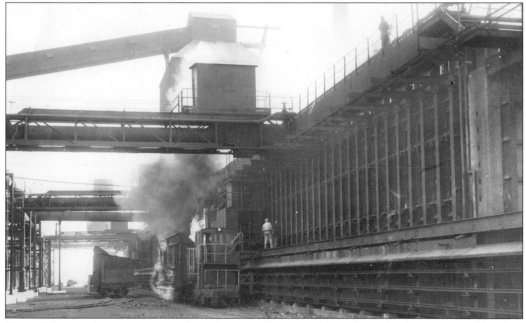

One of the nastiest places to work at Sparrows Point was the coke oven. It was incredibly hot and incredibly stinky. The author took a summer job here during college and didn't last a week. This photograph was taken in March 1953. (Courtesy Maryland Department, Enoch Pratt Free Library.)

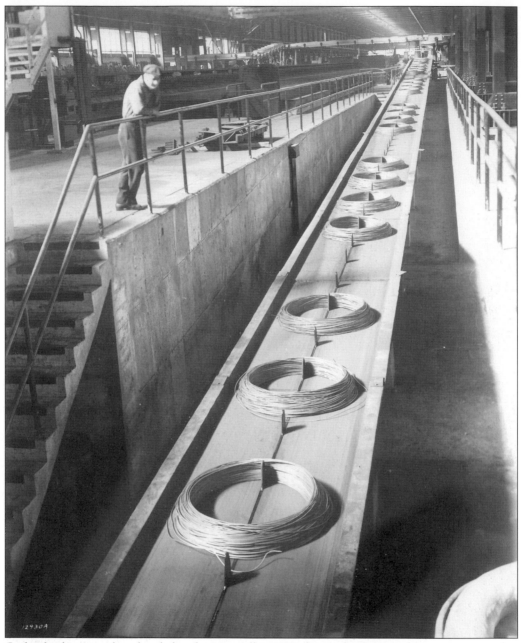

Coils of rod are seen here headed to the wire mill in 1938, destined to become fences, screws, staples, upholstery springs, and more. (Courtesy Maryland Department, Enoch Pratt Free Library.)

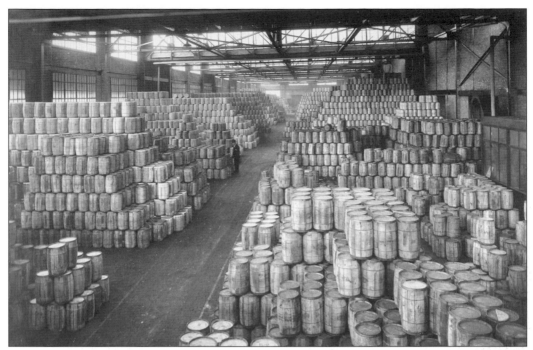

Nails made at Bethlehem were stored in wooden kegs and kept in this massive warehouse, ready to be shipped at a moment's notice. This photograph comes from 1934. (Courtesy Maryland Department, Enoch Pratt Free Library.)

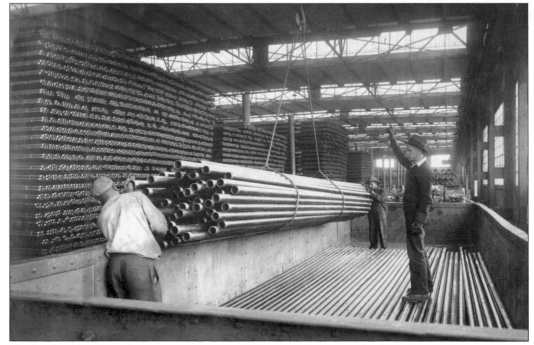

Under the direction of a supervisor, a pair of laborers is shown in this 1934 shot loading pipe into a railcar. In the early days of Sparrows Point, African American laborers were assigned the most menial, and lowest-paying, jobs. (Courtesy Maryland Department, Enoch Pratt Free Library.)

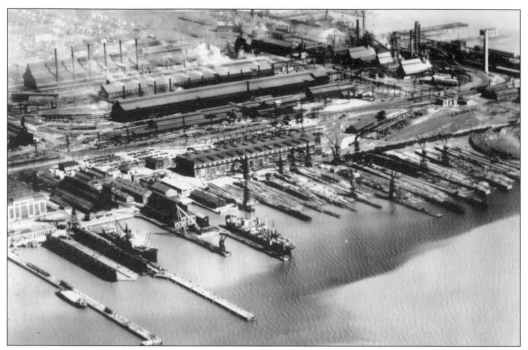

This aerial shot shows the shipyard in 1938. The Baltimore Beltway and Francis Scott Key Bridge now pass just to the left of this location. (Courtesy Maryland Department, Enoch Pratt Free Library.)

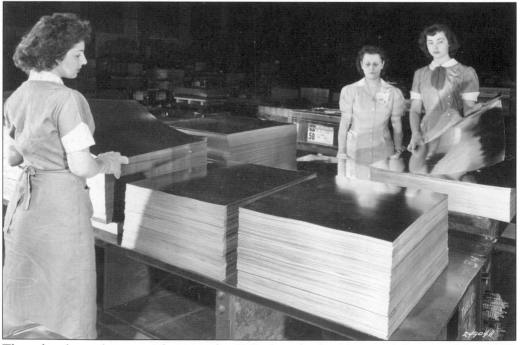

Three female employees are shown in this 1953 photograph sorting steel sheets in the tin mill. Women made up a large portion of the workforce here and were referred to as "Tin Floppers." (Courtesy Maryland Department, Enoch Pratt Free Library.)

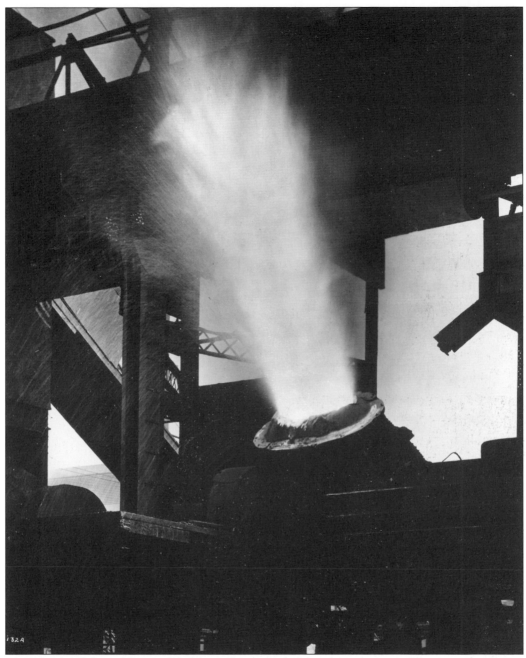

This awesome shot captures the "blowing" of a Bessemer converter to make certain grades of carbon steel. Molten iron was poured into the converter, then a shot of air was introduced at the bottom. As the air passed through the molten metal, some of the undesirable elements of the pig iron were burned out and escaped as gas, or they were removed as slag. Bethlehem had three Bessemer converters at Sparrows Point when this photograph was taken in March 1953. (Courtesy Maryland Department, Enoch Pratt Free Library.)

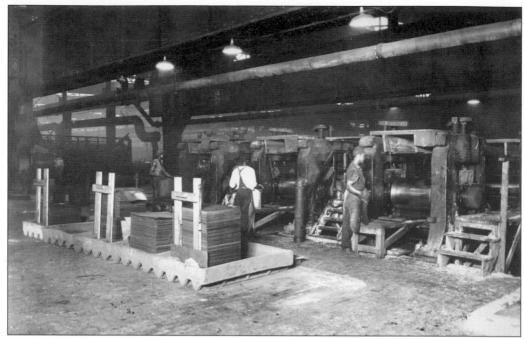

In the cold rolling mill, African American employees can be seen in a 1938 photograph awaiting the finished sheets of steel, which were then arranged in stacks. The employee at the right was an amputee. (Courtesy Maryland Department, Enoch Pratt Free Library.)

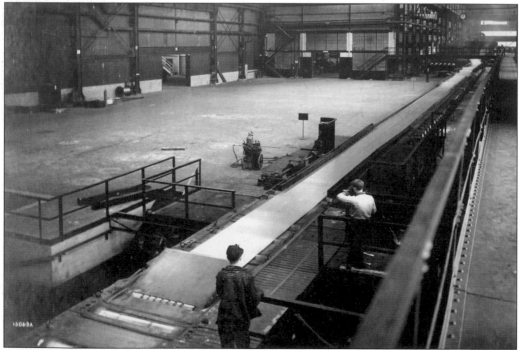

Here's a strip as it left the finishing stands in the hot mill, came down the run-out table, and entered coilers. The photograph was taken in 1938. (Courtesy Maryland Department, Enoch Pratt Free Library.)

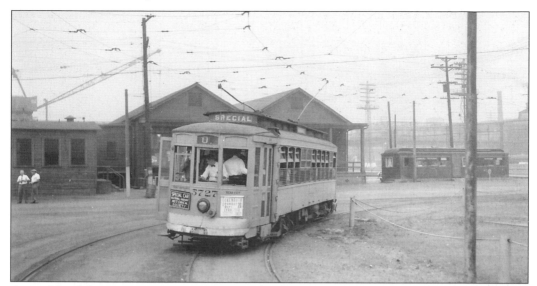

A special rail-fan excursion streetcar waits at the shipyard loop in this shot. This model car was manufactured by the J. G. Brill Company of Philadelphia between 1905 and 1919. Most had disappeared from Baltimore-area streets by the time this photograph was shot in 1953. (Courtesy Marian Zych.)

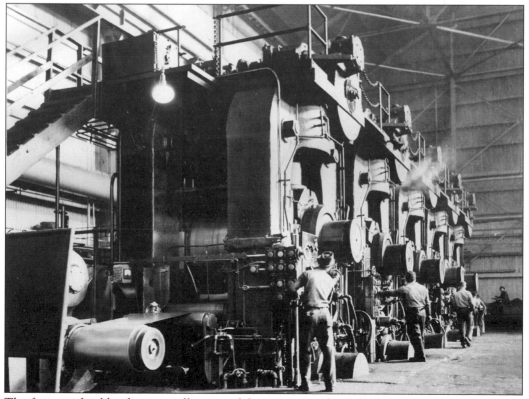

The five-stand cold-reduction mill was used for converting hot-rolled strip into highly polished cold-rolled strip. This photograph was taken in 1953. (Courtesy Maryland Department, Enoch Pratt Free Library.)

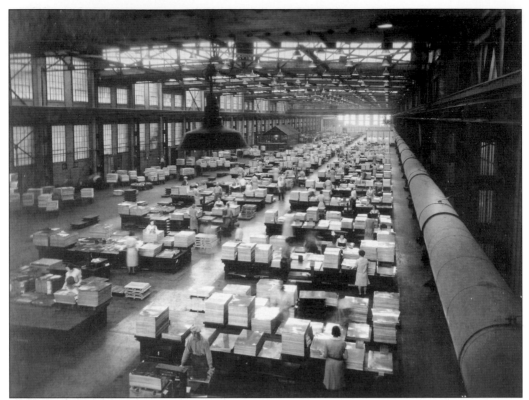

This huge facility was the tin sorting department, where "floppers" gave the product its final inspection before shipment. (Courtesy Maryland Department, Enoch Pratt Free Library.)

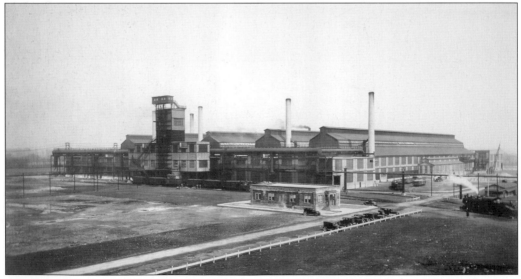

This was the pipe mill in 1938. A steam locomotive is visible in the lower right-hand corner. (Courtesy Maryland Department, Enoch Pratt Free Library.)

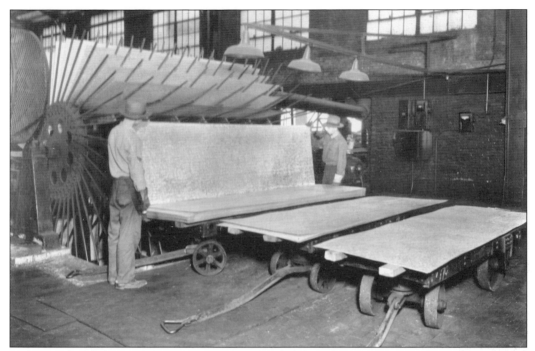

Galvanized steel sheets are being inspected in this shot from the 1930s. Again, despite the obvious dangers of the sharp-edged, heavy sheets, the only safety equipment protecting these workers was gloves. (Courtesy Maryland Department, Enoch Pratt Free Library.)

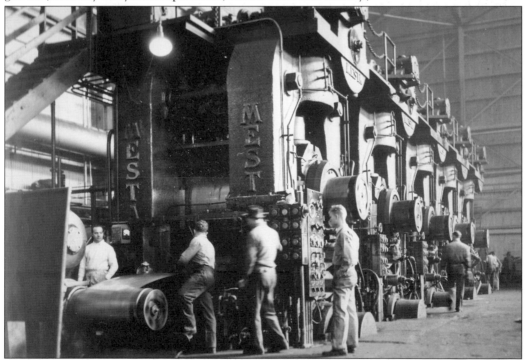

This 1930s photograph shows one of the five-stand tandem cold mills, where strip steel was made by pressure, not heat. (Courtesy Maryland Department, Enoch Pratt Free Library.)

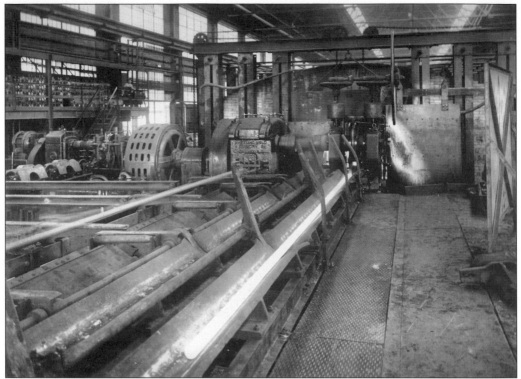

Here white-hot steel is seen running through a trough in the wire mill. This photograph was taken in 1930. (Courtesy Maryland Department, Enoch Pratt Free Library.)

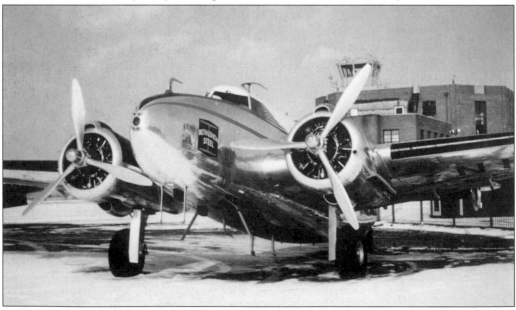

Bethlehem's DC-3 company plane waited on the tarmac at Dundalk's Harbor Field in this shot from the 1940s. Harbor Field was just across the water from Sparrows Point and served as Baltimore's municipal airport from 1941 to 1950. It is currently the site of Dundalk Marine Terminal. (Courtesy Dundalk–Patapsco Neck Historical Society Museum.)

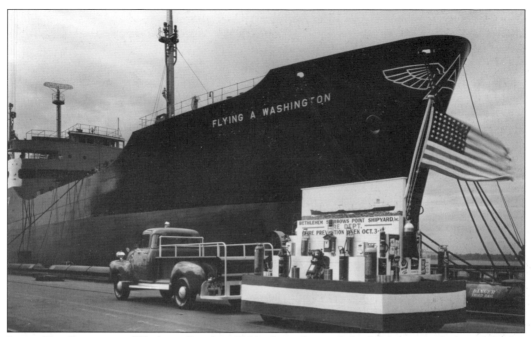

It was Fire Prevention Week in October 1954 when this mobile display parked alongside the tanker *Flying A Washington* at the Sparrows Point shipyard. Flying A gasoline disappeared from the American marketplace in the 1960s. (Courtesy Dundalk–Patapsco Neck Historical Society Museum.)

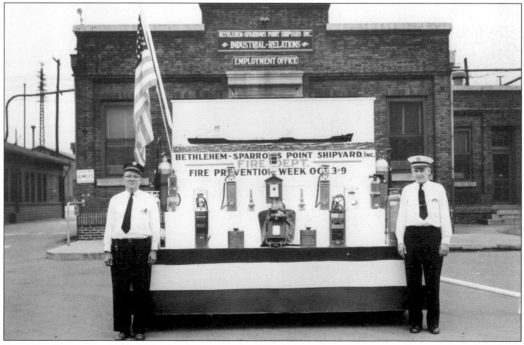

The Fire Prevention Week display has moved to the shipyard employment office in this shot from October 1954. The fire department personnel are not identified. (Courtesy Dundalk–Patapsco Neck Historical Society Museum.)

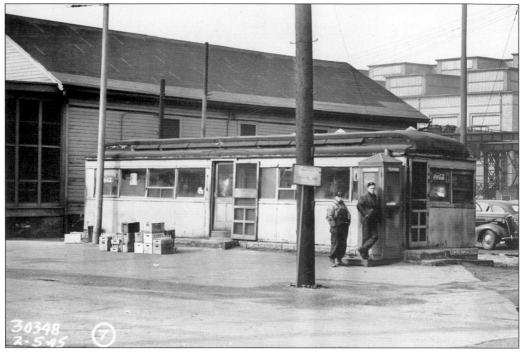

This converted streetcar served as a diner for hungry steelworkers in 1945. (Courtesy Dundalk–Patapsco Neck Historical Society Museum.)

Another spot for a quick bite was this cafeteria. It was situated near the wire and pipe mills. The photograph is from February 5, 1945. (Courtesy Dundalk–Patapsco Neck Historical Society Museum.)

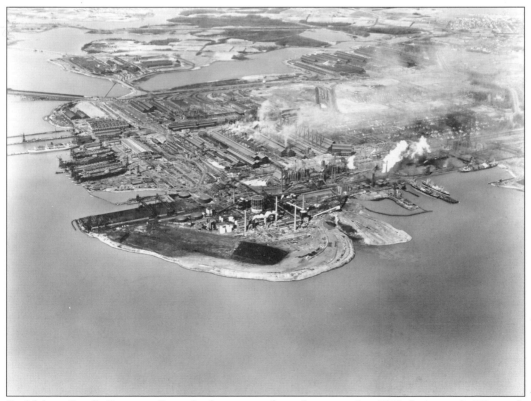

THE HOLDER OF THIS MERCHANDISE CREDIT COUPON BOOK

IS ENTITLED TO CREDIT

AT THE

SERVICE STORES CORPORATION

TO THE AMOUNT OF $5.00

SPARROWS POINT, MARYLAND

Acct. No._____ Issued to_____

Issued and OK'd by_____

N.º 265308Q

Date_____ 19____ Working No.

NOT TRANSFERABLE · NOT GOOD IF DETACHED

Here's an actual merchandise credit coupon book for use in the Sparrows Point company stores. Issued in 1942, it entitled the bearer to $5 in goods and merchandise. (Courtesy Dundalk–Patapsco Neck Historical Society Museum.)

Bethlehem Steel's Sparrows Point facility is seen from the air in this 1953 photograph. Through the smoke and haze, the town of Sparrows Point is clearly shrinking. (Courtesy Maryland Department, Enoch Pratt Free Library.)

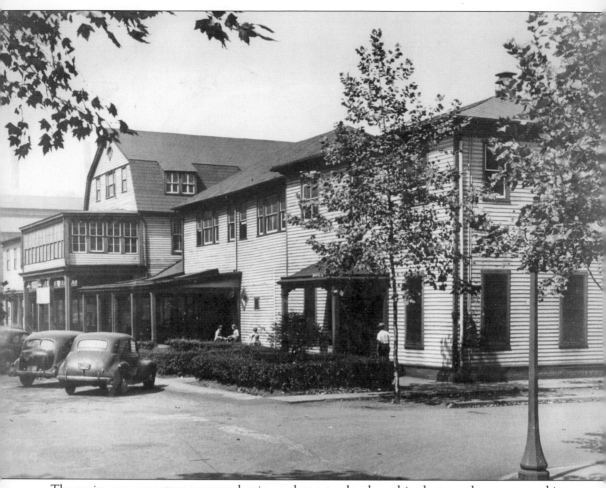

The main company store was conducting a closeout sale when this photograph was snapped in September 1944. Besides food, clothing, tobacco products, and groceries, the store was for years a general meeting place for residents of Sparrows Point. (Courtesy Dundalk–Patapsco Neck Historical Society Museum.)

Three

O LITTLE TOWN OF BETHLEHEM

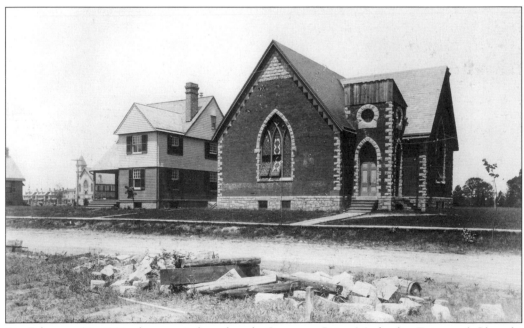

On February 22, 1889, the town's first church, Sparrows Point Methodist Episcopal Church, conducted its first services at Eighth and C Streets. This photograph, taken sometime before 1916, shows the church before its steeple was constructed. (Courtesy Dundalk–Patapsco Neck Historical Society Museum.)

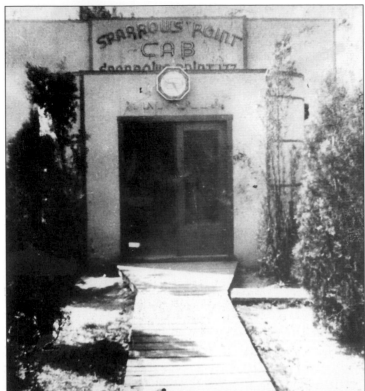

Ted Graff operated the Sparrows Point Cab Company and a number of other businesses in the area, including the Dundalk "Blue" Bus Line. This undated photograph is believed to be from the 1930s. (Courtesy Dundalk–Patapsco Neck Historical Society Museum.)

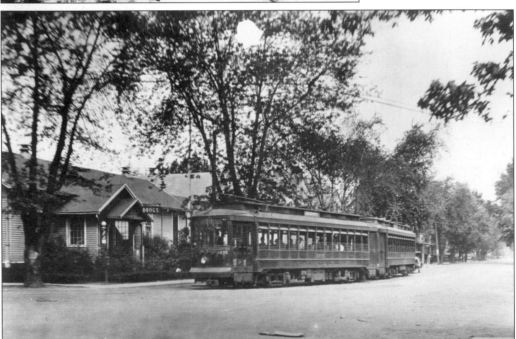

Locals referred to these streetcars as "Red Rockets." This one is making the turn at Fourth and D Streets. The drugstore on the corner was originally Sparrows Point's first public school building. (Courtesy Dundalk–Patapsco Neck Historical Society Museum.)

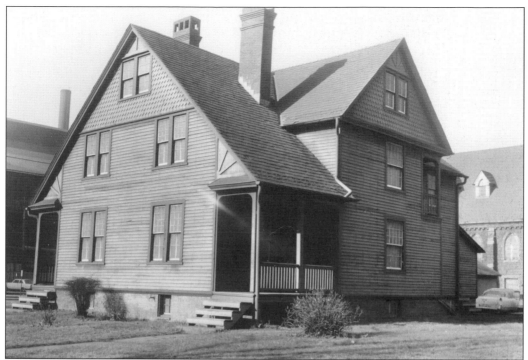

Bethlehem Steel's success at Sparrows Point was not without a price. Over time, plant expansion chipped away at the residential sections of town. Time was short for 506 and 508 E Street when this photograph was taken on December 14, 1964. (Courtesy Dundalk–Patapsco Neck Historical Society Museum.)

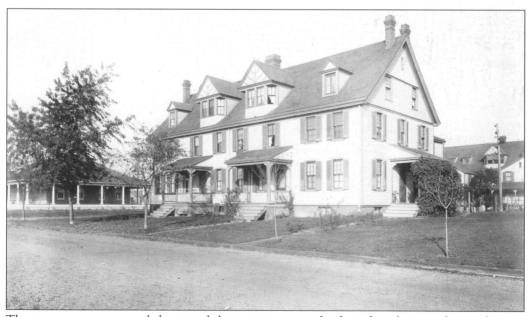

The trees were young and short, and the streets unpaved, when this photograph was shot on B Street sometime prior to 1920. That's the B Street Community Center at the left. (Courtesy Dundalk–Patapsco Neck Historical Society Museum.)

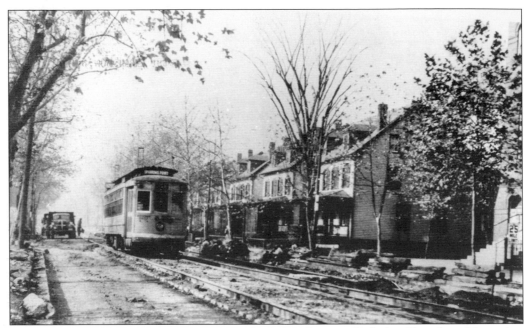

A streetcar rumbles east on D Street past St. Luke's Roman Catholic Church in November 1950. Paving work can be seen underway in the background. (Courtesy Dundalk–Patapsco Neck Historical Society Museum.)

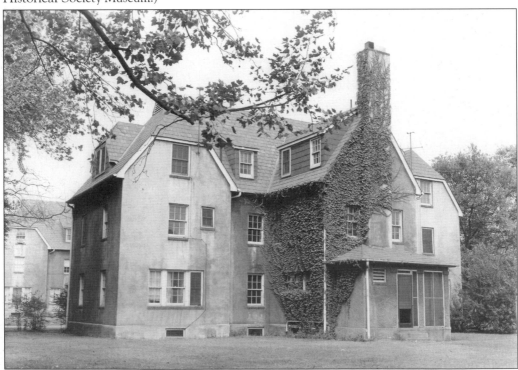

Originally built for borders, locals called this stucco dwelling one of the "white elephants." Converted into apartments during the 1930s, this one was at 903 E Street. The photograph is undated. (Courtesy Dundalk–Patapsco Neck Historical Society Museum.)

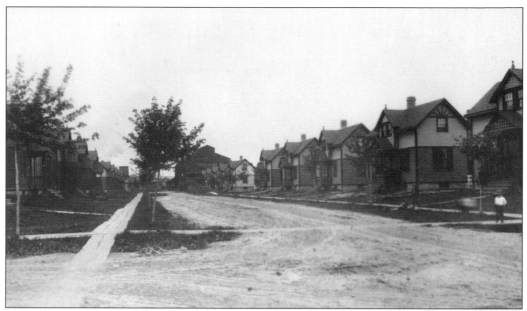

This shot looks west along H Street. Unpaved streets and boardwalks still existed when this photograph was taken around 1920. (Courtesy Dundalk–Patapsco Neck Historical Society Museum.)

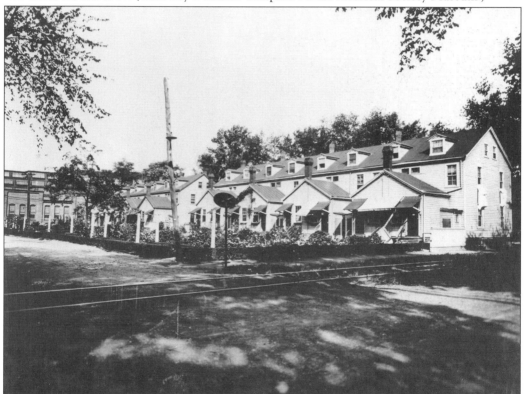

Railroad tracks cross E Street in this photograph from September 12, 1924. Children at play were brought up with a healthy respect for passing trains. (Courtesy Dundalk–Patapsco Neck Historical Society Museum.)

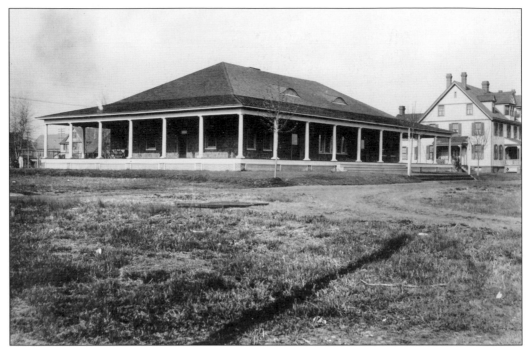

The B Street Community Center was also referred to as the Clubhouse. The local American Legion met there. And during the 1940s, dances were held inside for local teens. Admission was 25¢. Children loved to roller-skate around its porch but were usually chased away by Sparrows Point police. This image is undated. (Courtesy Dundalk–Patapsco Neck Historical Society Museum.)

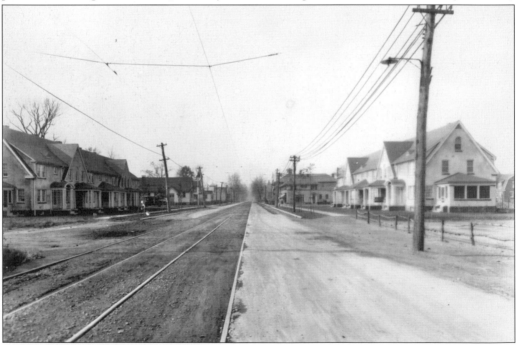

We're looking down D Street in this photograph snapped November 18, 1920. Middle- and lower-level managers lived on D Street. (Courtesy Dundalk–Patapsco Neck Historical Society Museum.)

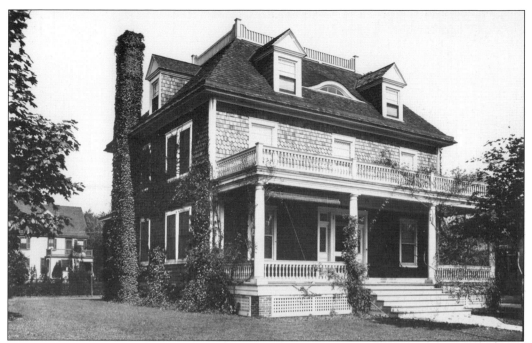

This beautiful example of a Sparrows Point home was located on C Street. The undated photograph is a testament to the care and craftsmanship used in the construction of homes that were designated for plant managers, in contrast to those built for African Americans on the North Side. (Courtesy Dundalk–Patapsco Neck Historical Society Museum.)

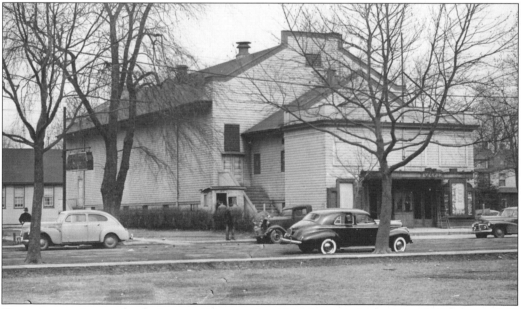

Time was running out for the Lyceum Theatre when this photograph was taken in February 1945. Opened in 1912, the Lyceum, at Fifth and D Streets, also featured an eight-lane duckpin bowling center in the basement. In 1947, the theater's roof partially collapsed after a heavy rain. Despite a full house, there were no injuries, but the theater never reopened. (Courtesy Dundalk–Patapsco Neck Historical Society Museum.)

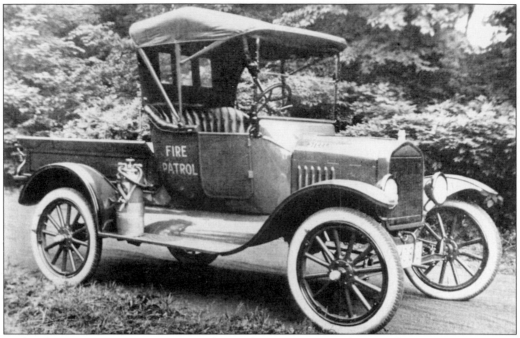

It's hard to imagine racing to a fire today in this. But in 1918, this was the Sparrows Point fire chief's car. (Courtesy Dundalk–Patapsco Neck Historical Society Museum.)

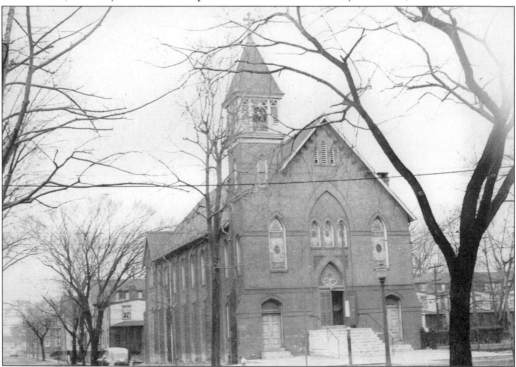

St. Luke's, at Sixth and D Streets, was built in 1889. The red brick church was one of the final buildings standing when Bethlehem Steel finished its consumption of the town of Sparrows Point in the 1970s. (Courtesy Dundalk–Patapsco Neck Historical Society Museum.)

This building once served as a dormitory for unmarried African American employees. It appears to have been abandoned by the time this photograph was taken, probably in the 1960s or 1970s. (Courtesy Dundalk–Patapsco Neck Historical Society Museum.)

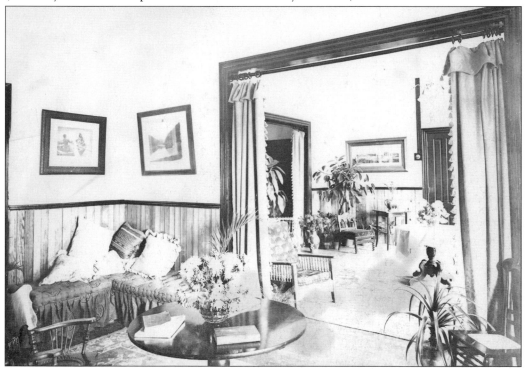

This could have been the lobby of an old, distinguished hotel. But it's actually an undated view of the interior of the B Street Community Center. (Courtesy Dundalk–Patapsco Neck Historical Society Museum.)

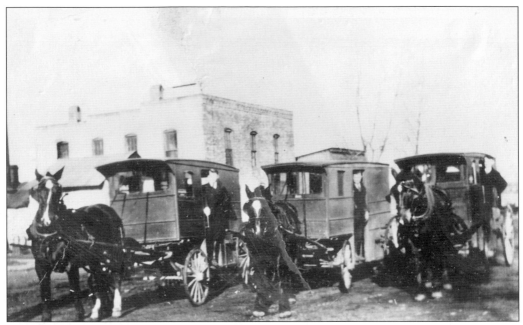

A trio of milkmen with their horses and wagons stand ready to make their morning rounds in this photograph from 1923. Sparrows Point had its own dairy, blacksmith shop, and slaughterhouse—all owned by Bethlehem. (Courtesy Dundalk–Patapsco Neck Historical Society Museum.)

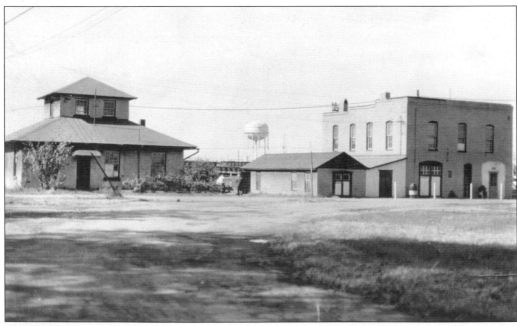

That's the dairy on the left and the blacksmith shop on the right. This shot was probably snapped in the 1930s or 1940s. (Courtesy Dundalk–Patapsco Neck Historical Society Museum.)

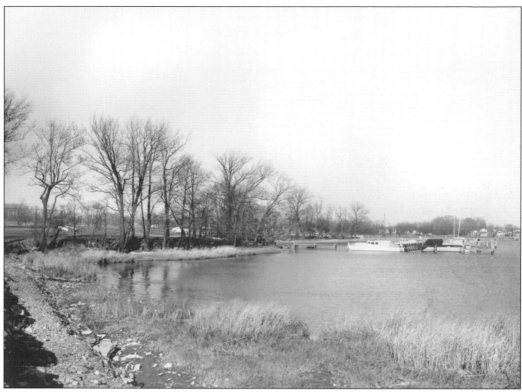

Plant managers received other perks besides better pay and working conditions and bigger, nicer houses. They could also join the Sparrows Point Country Club and perhaps tie up a private boat in Bear Creek alongside the golf course. This photograph was taken December 7, 1954. (Courtesy Dundalk–Patapsco Neck Historical Society Museum.)

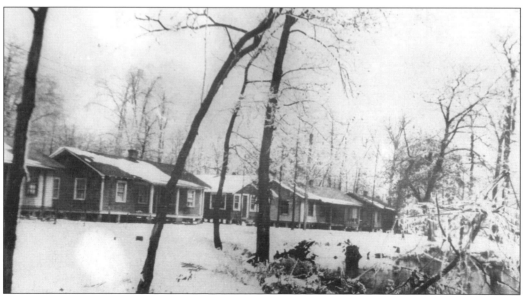

The bungalows were built in 1923. This shot, along Hadaway Road, was taken that same year. (Courtesy Dundalk–Patapsco Neck Historical Society Museum.)

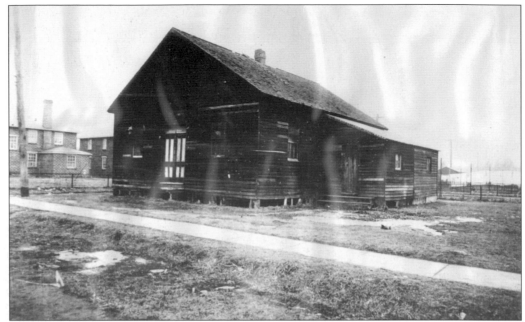

This was a dance hall on the town's North Side. The disparity in homes, accommodations, and employment opportunities between blacks and whites in early Sparrows Point was a sad reflection of the times. This photograph was taken February 3, 1920. (Courtesy Dundalk–Patapsco Neck Historical Society Museum.)

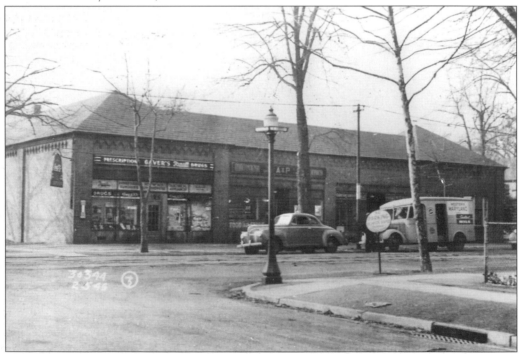

Gaver's Drug Store and the A&P Grocery stand on D Street in February 1945. While independent, they rented their retail space from Bethlehem Steel. (Courtesy Dundalk–Patapsco Neck Historical Society Museum.)

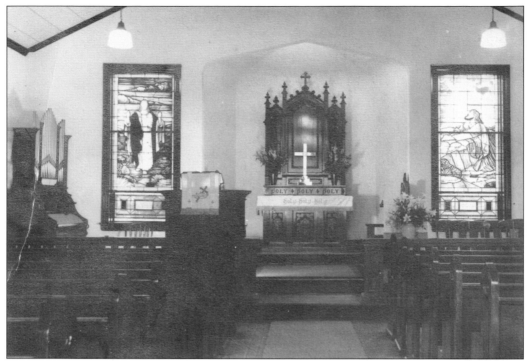

St. John's Evangelical Lutheran Church stood at Seventh and D Streets. This interior shot was taken around 1937. Forced to move because of plant expansion, the congregation built a new church in Edgemere on North Point Road. When they left, they took the altars and pews from the old sanctuary, along with four stained-glass windows. (Courtesy Marcee Zakwieia.)

This building, on the North Side, served as a barbershop for African Americans. It was photographed on February 3, 1920. (Courtesy Dundalk–Patapsco Neck Historical Society Museum.)

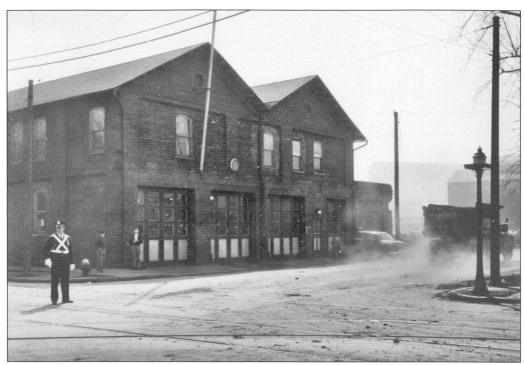

An officer directs traffic at Fourth and D Streets in this photograph from April 4, 1956, as a dump truck passes the town fire and police departments, kicking up dust in the process. (Courtesy Dundalk–Patapsco Neck Historical Society Museum.)

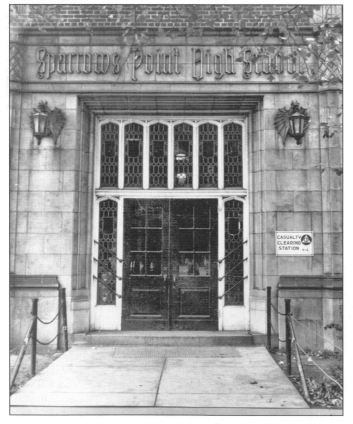

Sparrows Point High School was built in 1921. This undated picture is believed to be from the 1940s or 1950s, as evidenced by the Civil Defense placard on the wall, indicative of the cold war years. (Courtesy Sparrows Point High School Heritage Center.)

This 1930 photograph shows the town restaurant, the Beth-Mary Inn. After it closed, the building housed Bethlehem Steel's computer center. (Courtesy Dundalk–Patapsco Neck Historical Society Museum.)

By contrast, here's a 1920 photograph of the North Side restaurant and pool hall for African American residents of Sparrows Point. (Courtesy Dundalk–Patapsco Neck Historical Society Museum.)

On July 1, 1954, construction was underway for a new clubhouse for the Sparrows Point Country Club. The original clubhouse was once the home of a Dr. Trotten and was occupied by the British during the War of 1812. (Courtesy Dundalk–Patapsco Neck Historical Society Museum.)

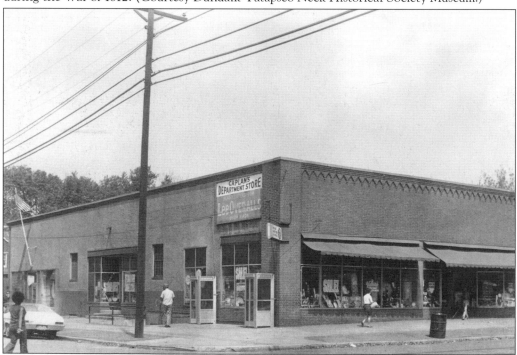

Caplan's Department Store was a popular destination for area shoppers. A "back-to-school" sale was underway when this photograph was taken in the late 1960s or early 1970s. (Courtesy Dundalk–Patapsco Neck Historical Society Museum.)

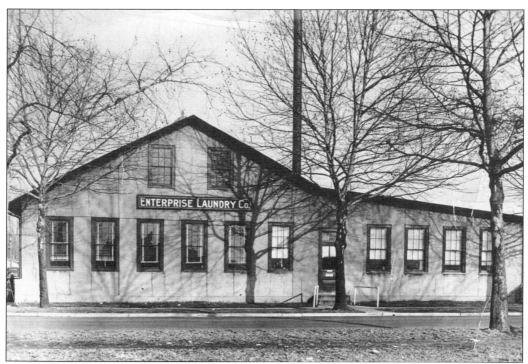

Enterprise Laundry was another longtime fixture in Sparrows Point. This photograph was shot during the 1930s. (Courtesy Dundalk–Patapsco Neck Historical Society Museum.)

That's Nick's Restaurant at Ninth and D Streets in 1972. Open 24 hours a day, it occupied the former site of Eddie's Supermarket, a local grocery chain. Provident Savings Bank was next door, to the left. (Courtesy Dundalk–Patapsco Neck Historical Society Museum.)

A number of businesses occupied this building at Tenth and I Streets. A barbershop was in the left corner. Tiger Press printing shop was at the right. And Kyle Lewis' Cleaning and Pressing was in the rear. This photograph was taken in the late 1960s or early 1970s. (Courtesy Dundalk–Patapsco Neck Historical Society Museum.)

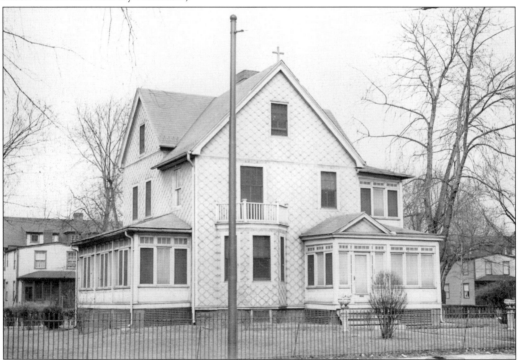

This is how St. Luke's Parsonage looked on Valentine's Day, 1945. St. Luke's was one of six churches in the company town. (Courtesy Dundalk–Patapsco Neck Historical Society Museum.)

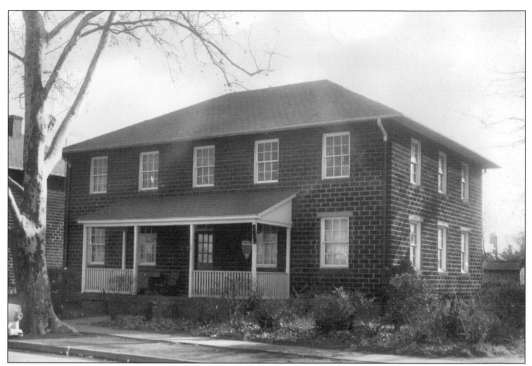

Here is a 1967 photograph of a Sparrows Point duplex. This unit was located at 901–903 J Street. (Courtesy Dundalk–Patapsco Neck Historical Society Museum.)

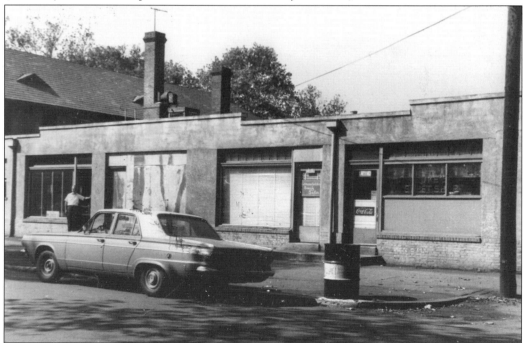

An unidentified man stands in the doorway to a barbershop in the 300 block of D Street in this shot from the 1960s. The business next door is boarded up. A beauty shop and Zuke's Sweet Shop are to the right. (Courtesy Dundalk–Patapsco Neck Historical Society Museum.)

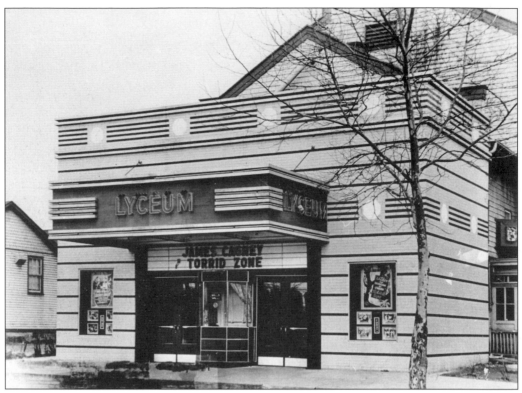

The Lyceum was showing a James Cagney film when this 1940 photograph was taken. The entrance to the basement duckpin bowling center is partially visible at the far right. (Courtesy Dundalk–Patapsco Neck Historical Society Museum.)

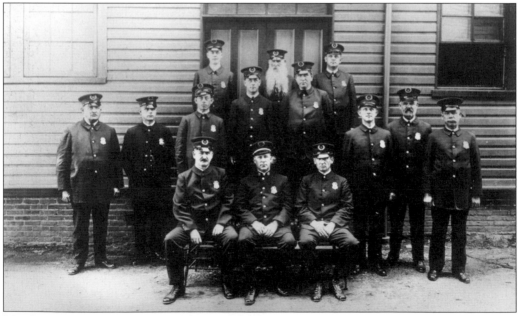

Members of the Sparrows Point Volunteer Fire Department sat for this group shot outside their D Street headquarters in 1916. (Courtesy Dundalk–Patapsco Neck Historical Society Museum.)

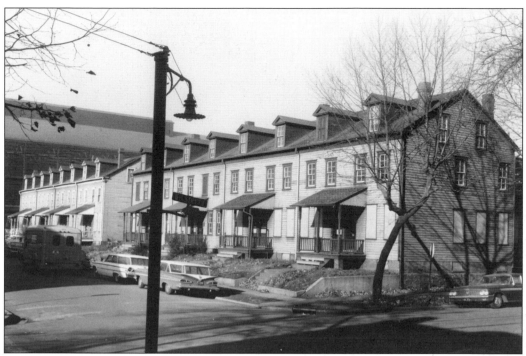

Several houses are boarded up in preparation for demolition in this photograph from Sixth and D Streets. It was taken December 1, 1966. (Courtesy Dundalk–Patapsco Neck Historical Society Museum.)

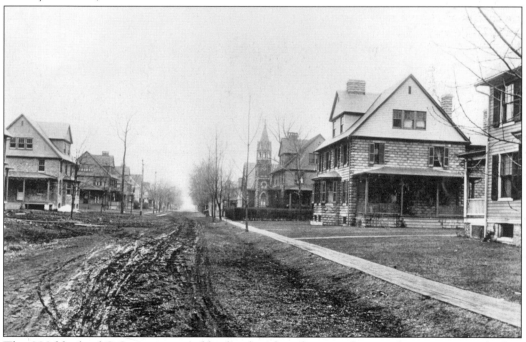

The 800 block of C Street was muddy the day this photograph was taken, sometime before 1920. The steeple of the First United Methodist Church is visible in the background. (Courtesy Dundalk–Patapsco Neck Historical Society Museum.)

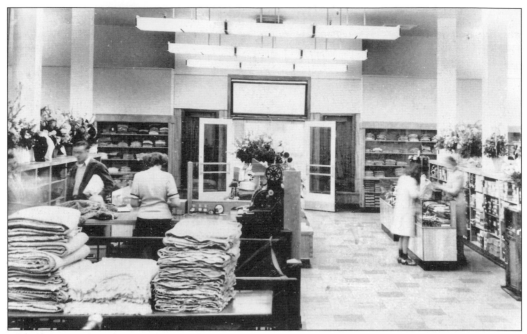

The interior of Caplan's is seen in this picture from the late 1940s or early 1950s. As a youngster, the author would accompany his father to the store. The author's father was a railroad freight conductor who bought a new hat at Caplan's once a year. (Courtesy Dundalk–Patapsco Neck Historical Society Museum.)

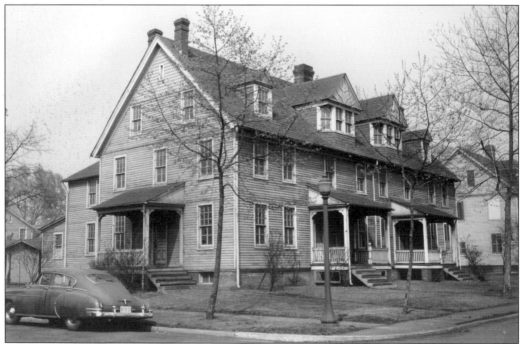

Here's the 500 block of B Street in April 1955. These homes were demolished to accommodate plant expansion shortly after this photograph was taken. (Courtesy Dundalk–Patapsco Neck Historical Society Museum.)

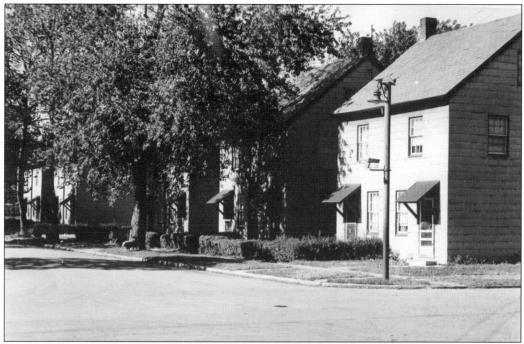

A lone dog can be seen wandering along J Street near the corner of Ninth Street in this photograph from the late 1960s or early 1970s. (Courtesy Dundalk–Patapsco Neck Historical Society Museum.)

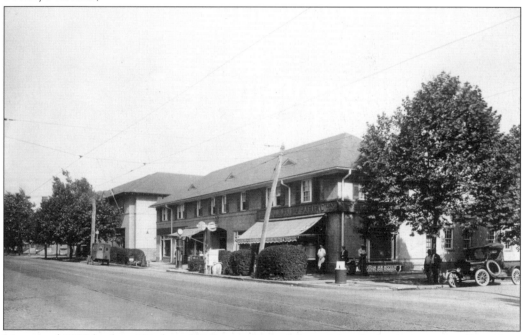

It's around 1928 back at Ninth and D Streets. From left to right, the businesses were Provident Savings Bank, Garber's Garage and Car Sales, and the A&P. The Odd Fellows and Masonic halls were on the second floor. Note the vintage gasoline pump in front of Garber's Garage. (Courtesy Dundalk–Patapsco Neck Historical Society Museum.)

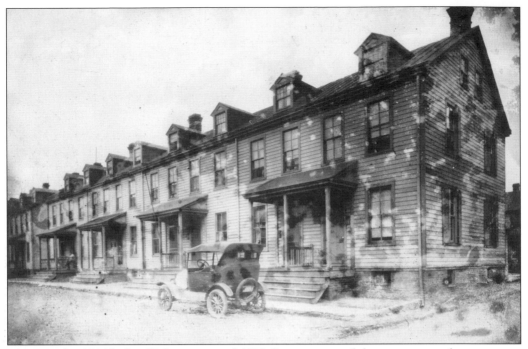

This was the 300 block of D Street around 1928. Private automobiles were rare and unnecessary at the time, as most could walk to work. (Courtesy Dundalk–Patapsco Neck Historical Society Museum.)

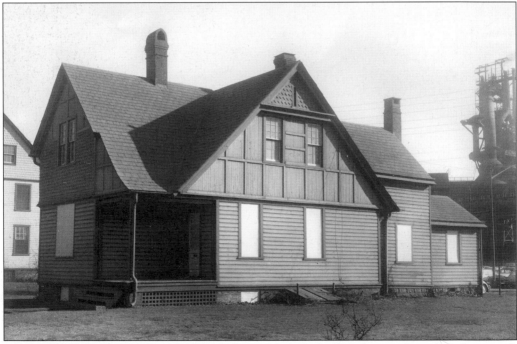

The building at 611 C Street was boarded up and ready for demolition when this photograph was taken on December 20, 1967. It came three weeks later. (Courtesy Dundalk–Patapsco Neck Historical Society Museum.)

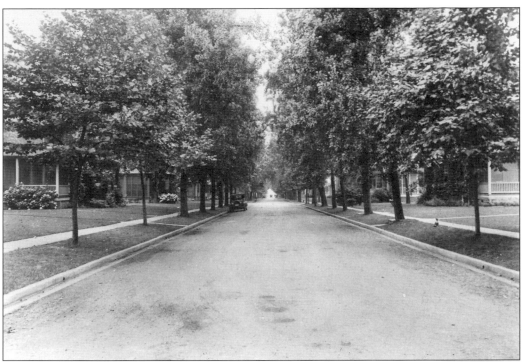

C Street looked empty and picturesque in this undated shot from the 1920s. It was taken between Sixth and Seventh Streets. (Courtesy Dundalk–Patapsco Neck Historical Society Museum.)

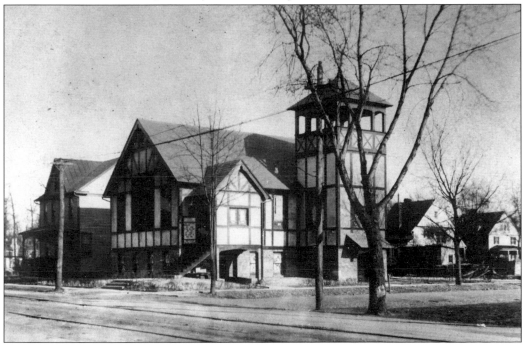

St. John's Evangelical Lutheran Church was at Seventh and D Streets. The original sanctuary was replaced by this structure in 1921. This photograph was taken shortly before demolition occurred, on December 28, 1971. (Courtesy Dundalk–Patapsco Neck Historical Society Museum.)

Another building waiting for demolition was this one, at 901–903 I Street on the North Side. An undated photograph, it is believed to be from the 1950s. (Courtesy Dundalk–Patapsco Neck Historical Society Museum.)

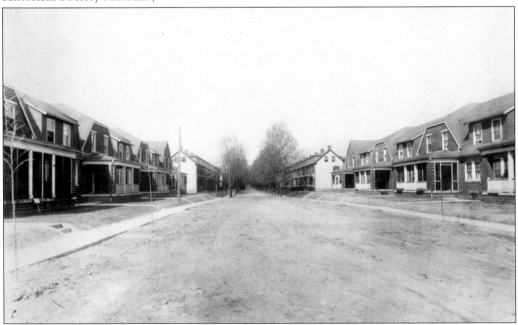

Newer homes and smaller, younger trees are in the foreground of this April 23, 1919, image of E Street. Cement sidewalks were in, but the road remained unpaved. (Courtesy Dundalk–Patapsco Neck Historical Society Museum.)

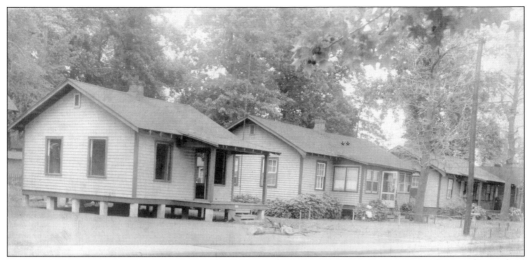

Here's another early, undated shot of the bungalows. Most tenants found the wooded setting a refreshing change from the noise and cramped environs found closer to the mills. (Courtesy Dundalk–Patapsco Neck Historical Society Museum.)

These homes, in the 500 block of B Street, were about to come down for plant expansion when this photograph was taken in April 1955. By June of that year, they were gone. (Courtesy Dundalk–Patapsco Neck Historical Society Museum.)

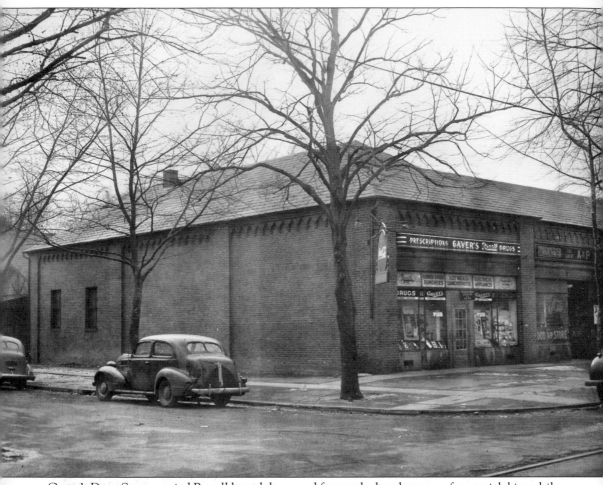

Gaver's Drug Store carried Rexall brand drugs and featured a luncheonette for a quick bite while the pharmacist filled your prescription. The local Western Union was also inside. (Courtesy Dundalk–Patapsco Neck Historical Society Museum.)

Four

LIFE AS A "POINTER"

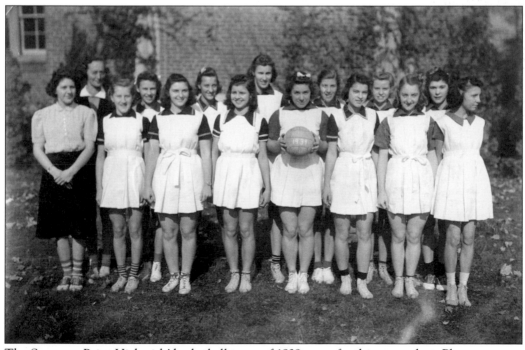

The Sparrows Point High girls' basketball team of 1939 poses for this group shot. Players are not identified. (Courtesy Sparrows Point High School Heritage Center.)

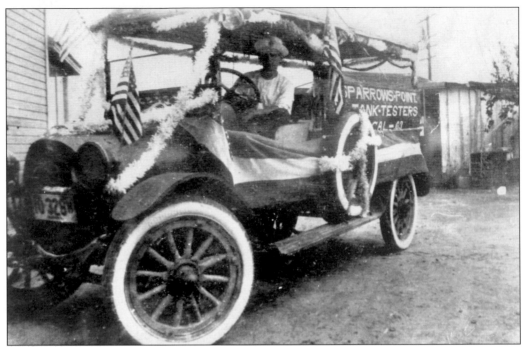

That is Joseph Roberts driving the Sparrows Point Tank Testers Local 63 truck, decorated for the Independence Day parade on July 4, 1917. The truck is a Reo, a name that disappeared decades ago. (Courtesy Dundalk–Patapsco Neck Historical Society Museum.)

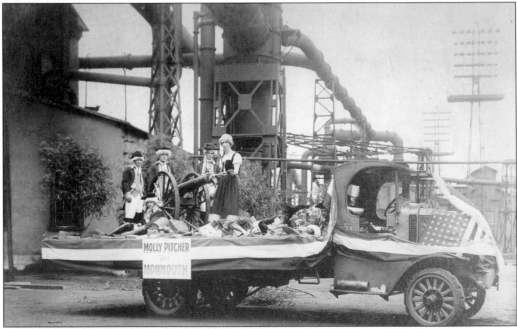

Another company truck features costumed employees as Revolutionary War soldiers and a woman as Mary Hays McCauly, known in history as "Molly Pitcher" for her contributions at the Battle of Monmouth in 1778. The undated photograph is believed to be from around 1920. (Courtesy Dundalk–Patapsco Neck Historical Society Museum.)

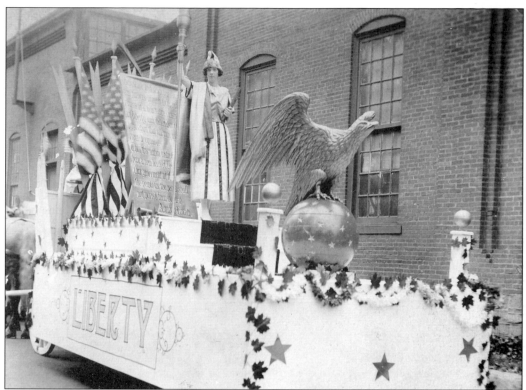

Here Lady Liberty is depicted atop another Independence Day float pulled by horses around 1920. Annual July 4 parades eventually moved to Dundalk and continue to this day. (Courtesy Dundalk–Patapsco Neck Historical Society Museum.)

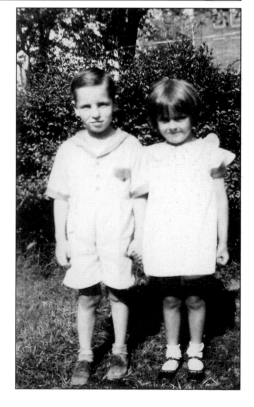

Brother and sister Ed and Carolyn Miller grew up at 525 E Street in Sparrows Point. They posed for this photograph outside their home around 1935. (Courtesy Marcee Zakwieia.)

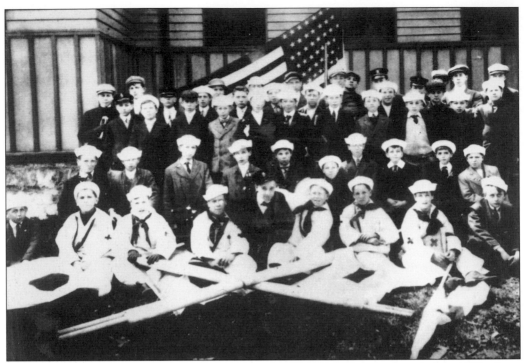

Sparrows Point is practically surrounded by water. Sea Scouting was founded in 1912, about the same time these Sparrows Point Sea Scouts posed for this group photograph. (Courtesy Dundalk–Patapsco Neck Historical Society Museum.)

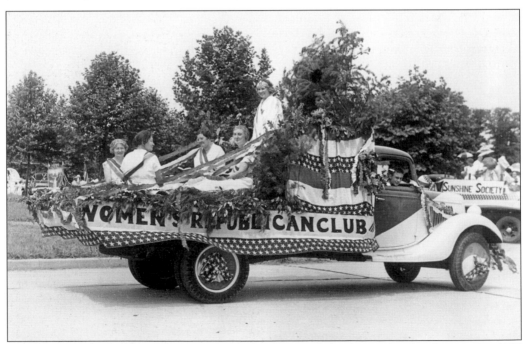

The Sparrows Point Women's Republican Club captured third prize for this float at the 1935 Independence Day parade. (Courtesy Dundalk–Patapsco Neck Historical Society Museum.)

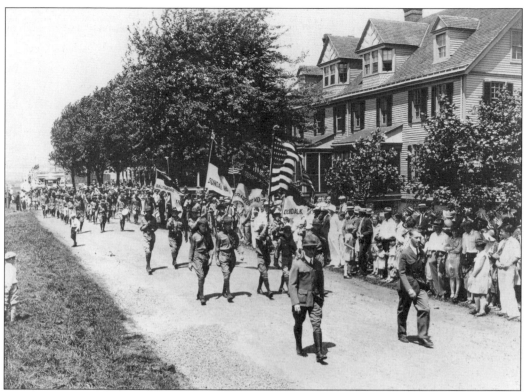

Boy Scouts from Sparrows Point, Dundalk, and Baltimore marched in this Independence Day parade in the late 1920s. The shade trees along B Street must have provided welcome relief from the oppressive heat and humidity of July. (Courtesy Dundalk–Patapsco Neck Historical Society Museum.)

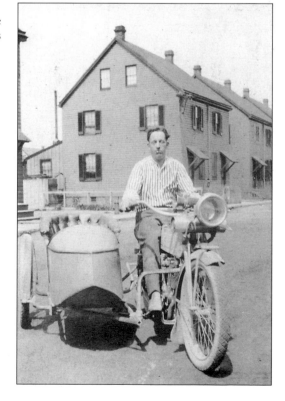

That's Ike Miller atop an early motorcycle and sidecar in this image from 1916. The photograph appears to have been taken in the shipyard area. (Courtesy Marcee Zakwieia.)

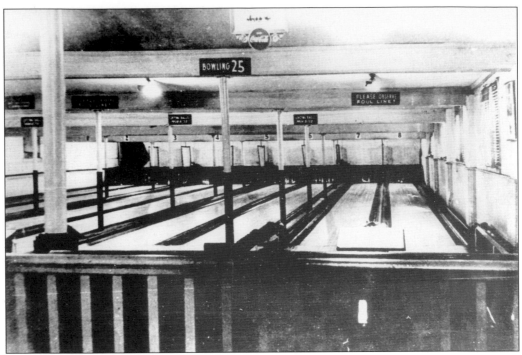

This was the eight-lane duckpin bowling center in the basement of the Lyceum Theatre on D Street, which closed with the theater in 1947. In the era before automatic pinsetters, James Miller, formerly of E Street, worked as a pin boy here. He recalled, "If you were lucky, the bowlers would slide a nickel down the alley at the end of the game." (Courtesy Dundalk–Patapsco Neck Historical Society Museum.)

James Miller posed for this photograph in his backyard at 525 E Street around 1935. The retired Bethlehem Steel salesman now lives in Jacksonville, Florida. (Courtesy Marcee Zakwieia.)

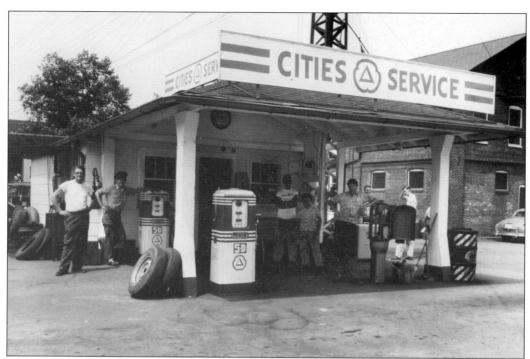

This was Pat Ward's gas station on July 19, 1955. That's Pat on the left, in the white T-shirt. The gas station was located at Fourth and C Streets. The Cities Service brand became Citgo in the 1960s. (Courtesy Dundalk–Patapsco Neck Historical Society Museum.)

James Wengred and Pat Miller were chosen "Best Dressed of 1954" by their classmates at Sparrows Point High. (Courtesy Sparrows Point High School Heritage Center.)

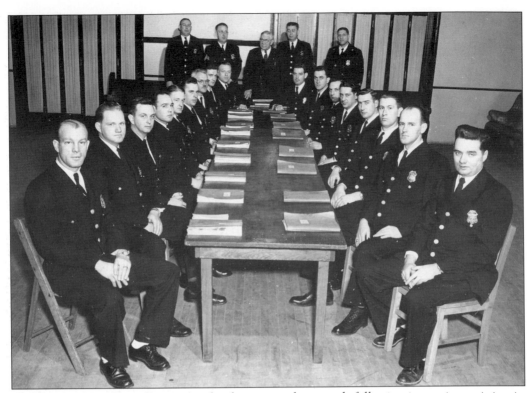

Sparrows Point police officers pose for this group photograph following in-service training in January 1954. Frank Zakwieia, who donated this shot, is seated sixth from the left. Chief of Police Miles is standing at the head of the table. (Courtesy Frank Zakwieia.)

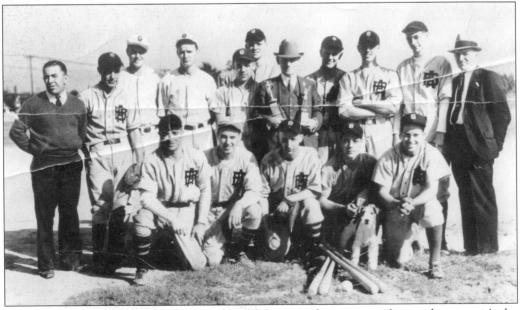

Another group photograph is shown of Bethlehem employees in uniform—this time it's the accounting department baseball team of 1937, champions of the Inter Club League of Baltimore that year. (Courtesy Dundalk–Patapsco Neck Historical Society Museum.)

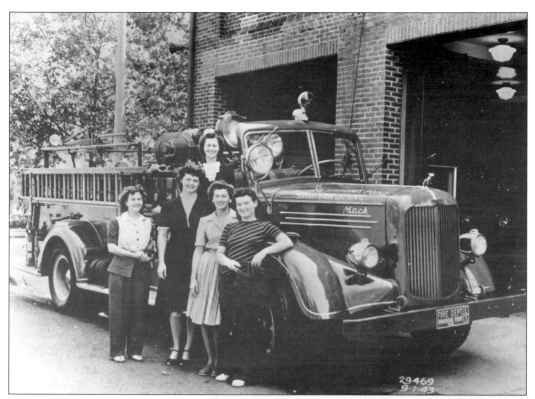

These unidentified ladies were selected "Fire House Beauty Queens." They're shown posing with a Mack fire engine at the shipyard fire department on September 1, 1943. (Courtesy Dundalk–Patapsco Neck Historical Society Museum.)

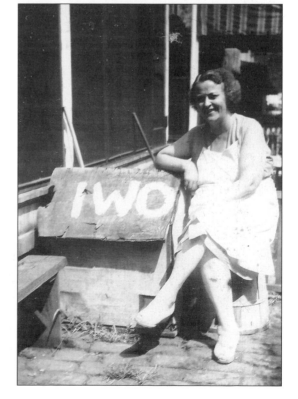

Marie Miller strikes a pose alongside the family dog's house in the yard of her E Street home. Iwo the dog got his name courtesy Miller's son Archie, who participated in the battle for Iwo Jima as a member of the U.S. Marine Corps during World War II. (Courtesy Marcee Zakwieia.)

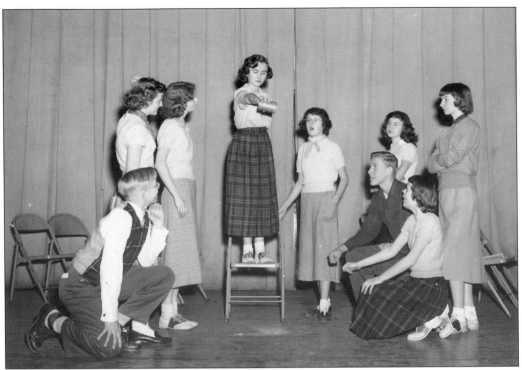

Our Miss Brooks was a popular radio program starring Eve Arden during the late 1940s and early 1950s. In the 1951–1952 school year, it became a production at Sparrows Point High, with Eva Jane Wheeler (center) playing the title role. (Courtesy Sparrows Point High School Heritage Center.)

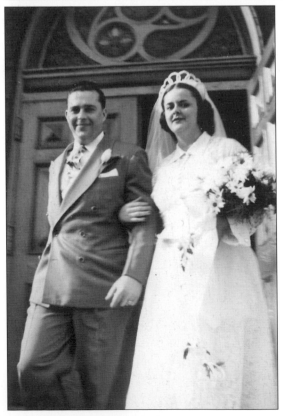

Frank Zakwieia and the former Carolyn Miller exit St. Luke's Church on D Street following their 1951 wedding. The marriage lasted 53 years until Carolyn's death in 2004 and produced three daughters, two grandchildren, and one great-grandson, so far. (Courtesy Frank Zakwieia.)

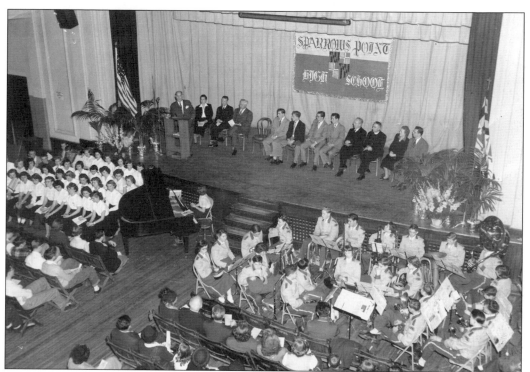

In 1951, Sparrows Point High School conducted a special assembly for seniors about to depart for the Korean War. A dozen former Sparrows Point High students would die in that conflict, compared with 105 from the school that were killed or reported missing in action during World War II. (Courtesy Sparrows Point High School Heritage Center.)

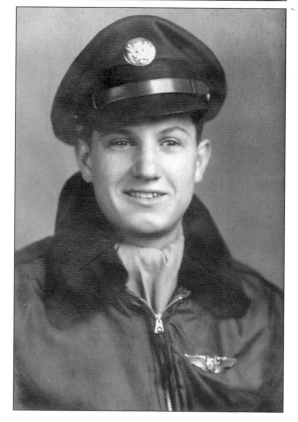

Forrest L. Dobbin of the class of 1945 sent this photograph to his favorite teacher at Sparrows Point High, Evelyn Schutz. On the back he inscribed, "To the best teacher I ever had, from your worst student." (Courtesy Sparrows Point High School Heritage Center.)

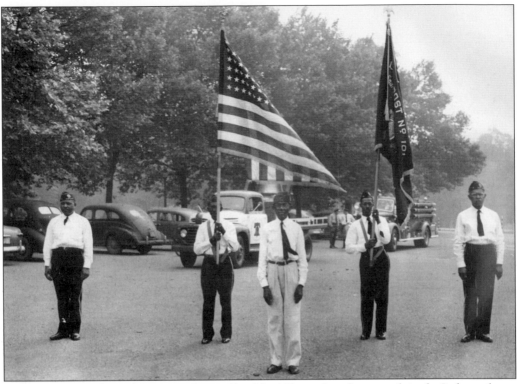

Unidentified members of American Legion Post No. 101 stand ready to march in the Independence Day parade, July 1, 1950. (Courtesy Dundalk–Patapsco Neck Historical Society Museum.)

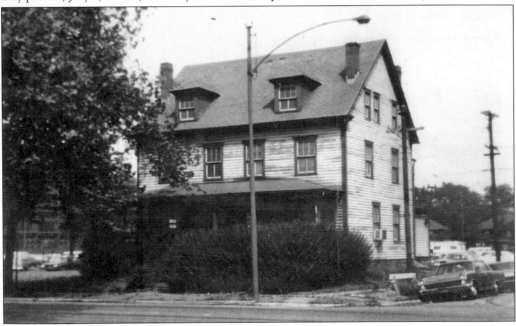

The offices of Dr. Roger Windsor and his associate, Dr. Means, occupied this structure at Sixth and D Streets. This photograph was taken just before demolition in the late 1960s. (Courtesy Dundalk–Patapsco Neck Historical Society Museum.)

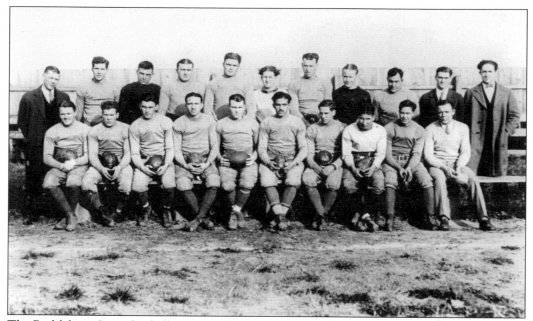

The Bethlehem Grays football team won four, lost none, and tied once during their 1926 season. Their coach was "Dutch" Hentschen, standing at the left in the back row. (Courtesy Dundalk–Patapsco Neck Historical Society Museum.)

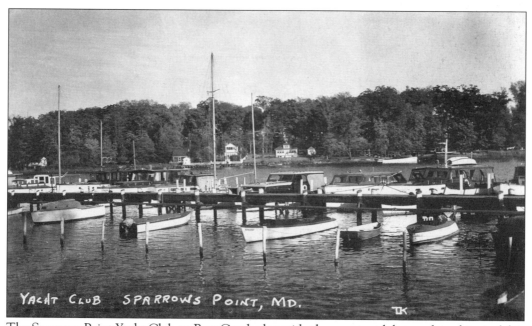

The Sparrows Point Yacht Club, at Bear Creek alongside the country club, was the subject of this undated photograph believed to be from the 1930s. (Courtesy Dundalk–Patapsco Neck Historical Society Museum.)

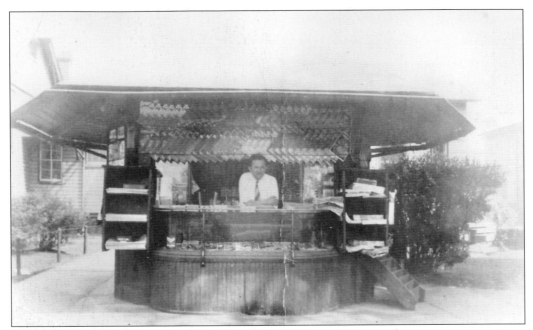

Gabe Banks operated the newsstand at Fourth and D Streets. It featured newspapers, magazines, cigars, and cigarettes. The photograph is undated. (Courtesy Dundalk–Patapsco Neck Historical Society Museum.)

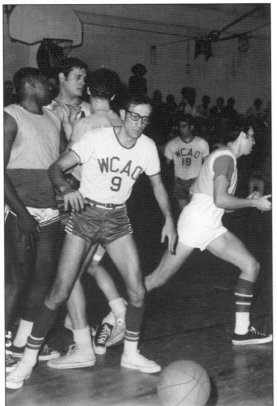

Max Byrd (9) looks at the loose ball in this 1969 basketball game between radio station WCAO and the Sparrows Point High School (SPHS) faculty. Legendary DJ Johnny Dark coached the WCAO "Good Guys," who played throughout the Baltimore area to help schools and organizations raise funds. He recalls that Byrd was a "ringer," a non-employee enlisted to play because there weren't enough people at the station. The SPHS faculty went on to win this day. (Courtesy Sparrows Point High School Heritage Center.)

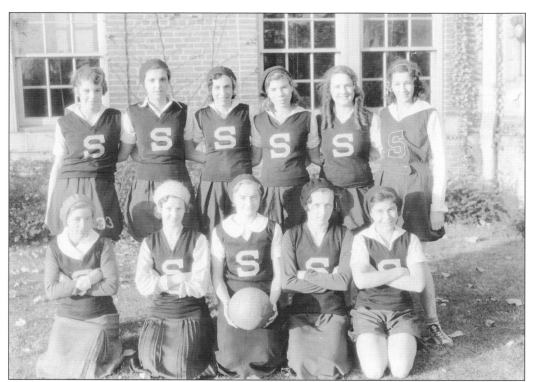

The SPHS field ball team in 1931 was, from left to right, (first row) Alverta Eckstein, Jessie Nolan, Elsie Stratmann, Ruth McDonough, and Mildred Swope; (second row) Helen Owens, unidentified, Bertha Isenock, Sara Godwin, Sis Jackson, and Hortense Mahoney. (Courtesy Sparrows Point High School Heritage Center.)

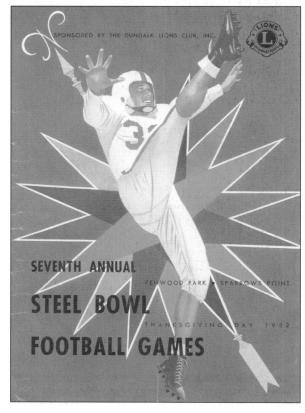

The Steel Bowl football games were a Thanksgiving Day tradition established in the 1940s. They pitted members of the Sparrows Point YMCA against those from the Dundalk Y. This was the program cover for the 1952 games. (Courtesy Sparrows Point High School Heritage Center.)

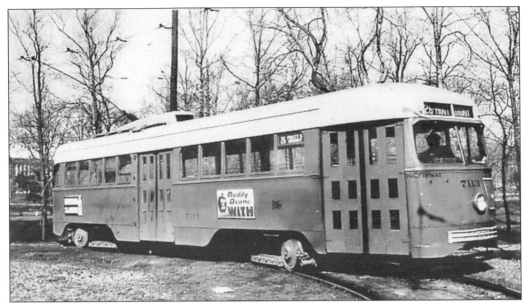

The Baltimore Transit Company succeeded United Electric Railways as the private operator of Baltimore's buses and streetcars. Here streamlined PCC (Presidential Coach Car) streetcar No. 7113 waits at the Sparrows Point loop, ready to make its return trip to Highlandtown. An advertisement on the side promotes legendary DJ Buddy Deane on WITH radio. Deane, the inspiration for the movie and stage play *Hairspray*, died in 2003, and WITH is now WRBS-AM, airing religious programming. (From the author's collection.)

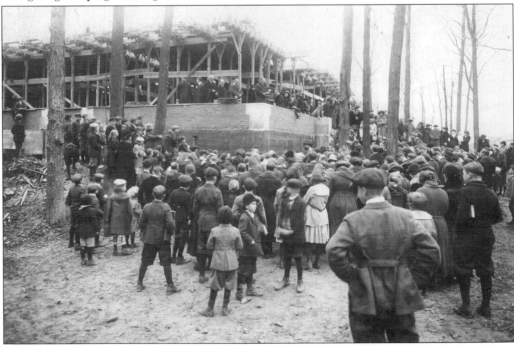

A large crowd was on hand November 23, 1921, as officials dedicated the cornerstone at the site of the new (now old) Sparrows Point High School. The cornerstone was salvaged when the school was demolished in the 1970s. (Courtesy Sparrows Point High School Heritage Center.)

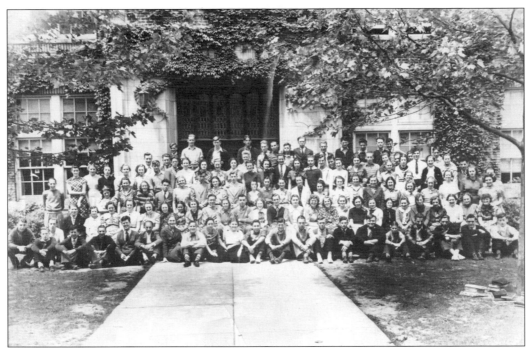

Here's a group shot of the Sparrows Point High class of 1937, taken in front of the school. (Courtesy Sparrows Point High School Heritage Center.)

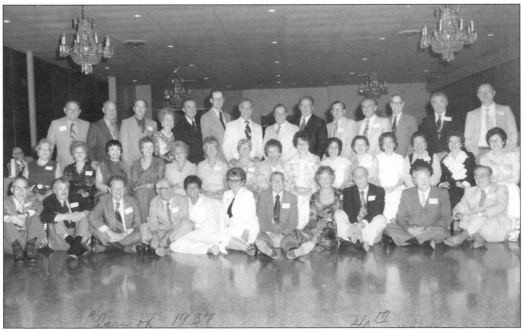

Forty years later, many of those same men and women gathered for the class of 1937's 40th reunion in 1977. The Heritage Center at the Sparrows Point High School library has a large collection of class photographs, yearbooks, pins, rings, and more. The alumni association oversees the center, which is open to the public. (Courtesy Sparrows Point High School Heritage Center.)

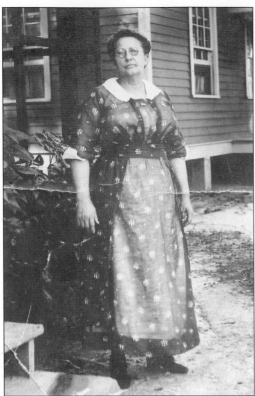

Mary Miller was of German ancestry. Attracted to Sparrows Point by the promise of good wages and affordable housing, she was the first of three generations to call it her home. This undated photograph is believed to be from the 1920s. (Courtesy Marcee Zakwieia.)

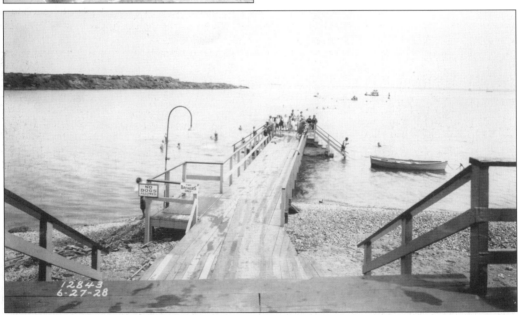

The Sparrows Point Bathing Beach offered this long wooden pier, with steps dropping down into the Patapsco River, for welcome relief from the summer heat and humidity. The legendary Bay Shore Park was close by until Bethlehem bought the property and closed it in 1947 for a planned expansion that never occurred. This shot of the Sparrows Point beach was taken June 27, 1928. (Courtesy Dundalk–Patapsco Neck Historical Society Museum.)

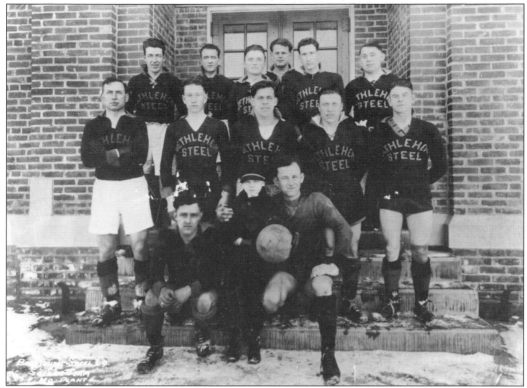

On a cold, snowy day in February 1930, the Bethlehem Steel soccer team posed for a team photograph. In the early days, Bethlehem Steel strongly encouraged organized team sports. (Courtesy Dundalk–Patapsco Neck Historical Society Museum.)

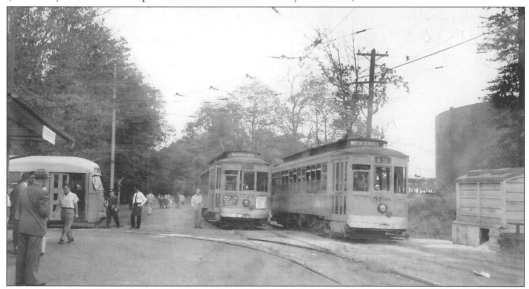

The past and present meet at the Sparrows Point station in this 1953 photograph. Special rail-fan streetcars—the old Brill models—wait at the center and right, while a modern PCC car sits at the left. Former Pointer Jimmy Miller recalled, "We thought we were hot stuff when those new streetcars came to the Point." (Courtesy Marian Zych.)

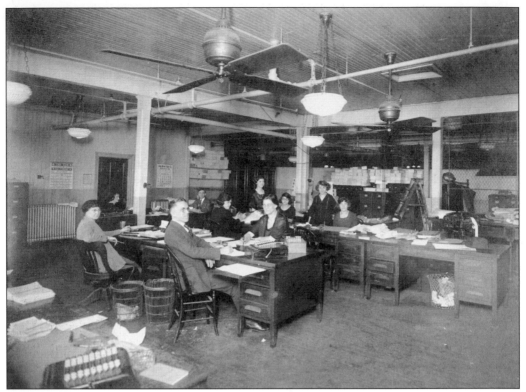

This rare shot was taken inside the office of the main company store. The year was 1944. (Courtesy Dundalk–Patapsco Neck Historical Society Museum.)

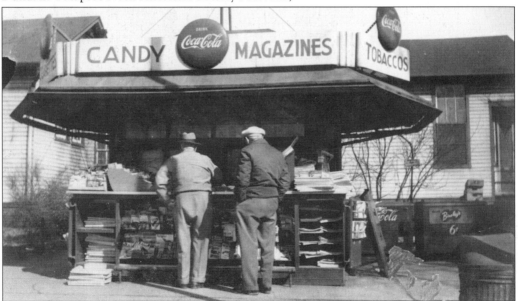

The old newsstand at Fourth and D Streets was now called the Popular News and Confection Stand when this photograph was taken, probably in the 1950s. Bireley's orange and grape sodas were available from a cooler for 6¢, as was Coca-Cola. (Courtesy Dundalk–Patapsco Neck Historical Society Museum.)

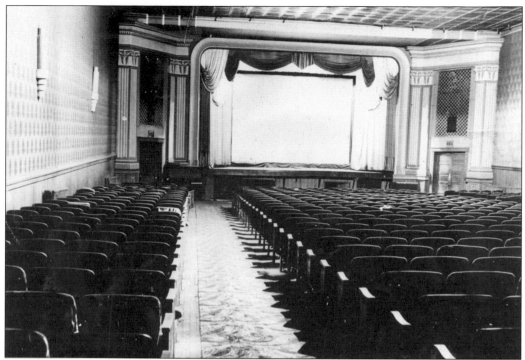

Here is an interior shot of the Lyceum Theatre. Opened in 1912, it was a favorite destination for dates until it closed in 1947. (Courtesy Dundalk–Patapsco Neck Historical Society Museum.)

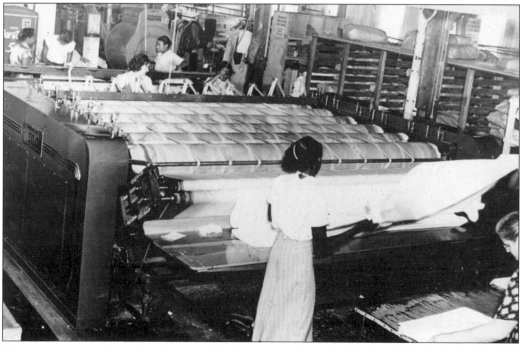

Sheets were pressed in this photograph taken inside Enterprise Laundry. The work was hot and sometimes dangerous. The undated photograph is believed to be from the 1940s or 1950s. (Courtesy Dundalk–Patapsco Neck Historical Society Museum.)

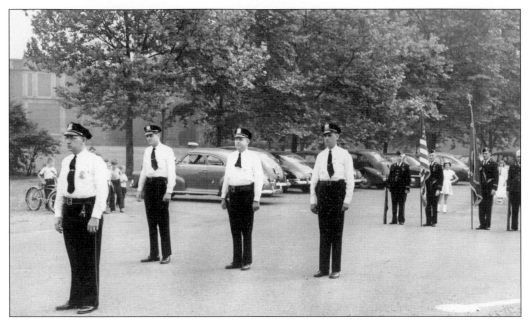

Sparrows Point police officers get ready to march in the 1950 Independence Day parade. From left to right, the officers are Schultheis, McAdams, Clemson, and Hagerman. (Courtesy Dundalk–Patapsco Neck Historical Society Museum.)

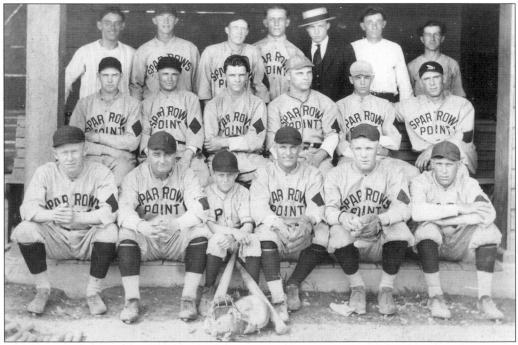

Another vintage photograph shows Sparrows Point's "AA" baseball team in 1921. From left to right are (first row) Dan Kelly, John Malley, Dan Carlin (bat boy), D. Miller, Bill Hanna, and Erwin Oberle; (second row) Joe Sullivan, George Woodhead, Bill Strasbaugh, Harry Strasbaugh, Len Woodhead, and Hawk Fisher; (third row) Al Legrant, Joe Tagg, Toddy Cox, Babe Baldwin, Vic Deihm, Bill Tagg, and Dick Gephardt. (Courtesy Dundalk–Patapsco Neck Historical Society Museum.)

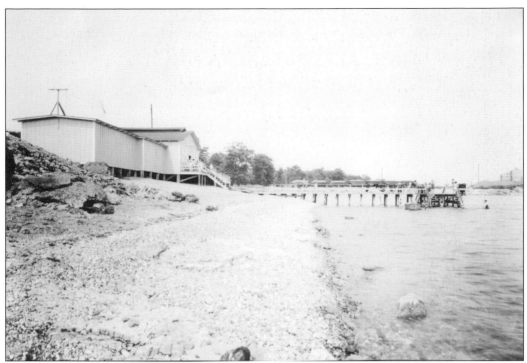

Here's another view of the Sparrows Point Bathing Beach. This one was taken from the vicinity of the ore piers on June 27, 1928. (Courtesy Dundalk–Patapsco Neck Historical Society Museum.)

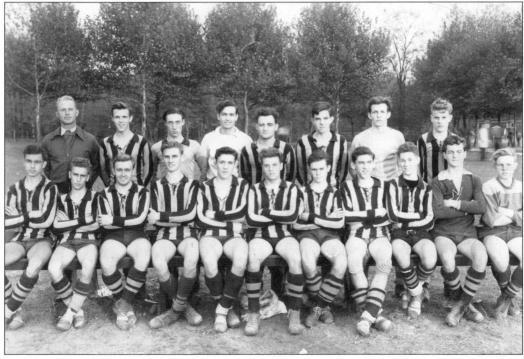

Another team photograph features the Sparrows Point High soccer team from 1941. (Courtesy Sparrows Point High School Heritage Center.)

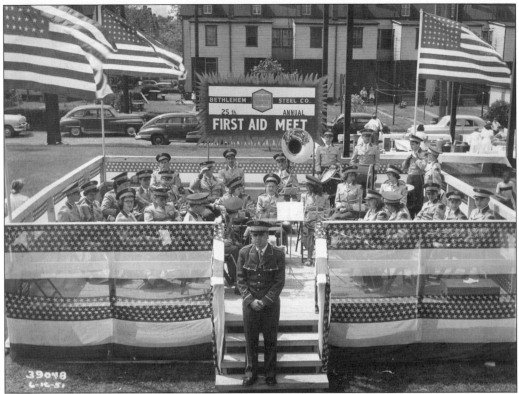

The Sparrows Point High School band is all set to perform at Bethlehem Steel's 25th annual First Aid Meet on June 16, 1951. (Courtesy Sparrows Point High School Heritage Center.)

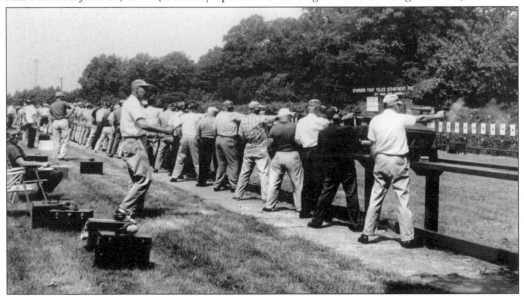

Each year, the Sparrows Point Police Department hosted firearms competitions at their pistol range. Officers from dozens of police agencies in the region participated. This photograph was shot (no pun intended) on June 20, 1964. (Courtesy Dundalk–Patapsco Neck Historical Society Museum.)

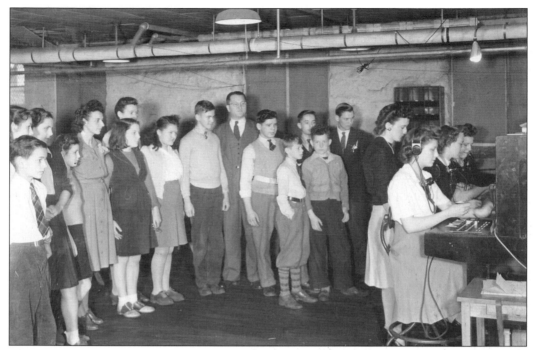

The Sparrows Point Telephone Exchange was displaced by a fire in 1945 and temporarily relocated to the basement of the high school. On this day, teachers and students paid a visit to see how operators "operated." (Courtesy Dundalk–Patapsco Neck Historical Society Museum.)

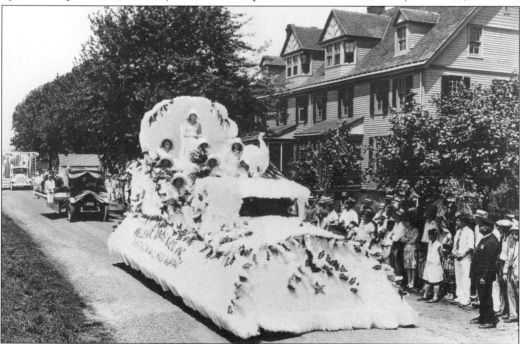

Pointers certainly enjoyed parades. Here's another Independence Day in the late 1920s, with elaborately decorated floats heading down B Street. (Courtesy Dundalk–Patapsco Neck Historical Society Museum.)

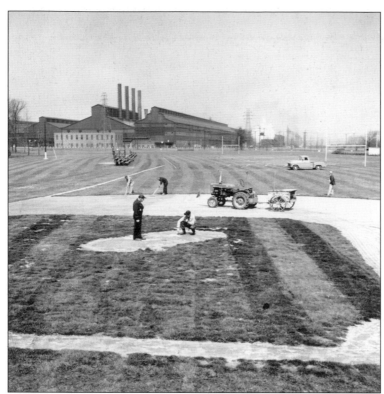

Grounds crew members were busy readying Penwood Park (also spelled Pennwood) for a baseball game when this photograph was taken around 1957. That's the hot strip mill in the background. (Courtesy Dundalk–Patapsco Neck Historical Society Museum.)

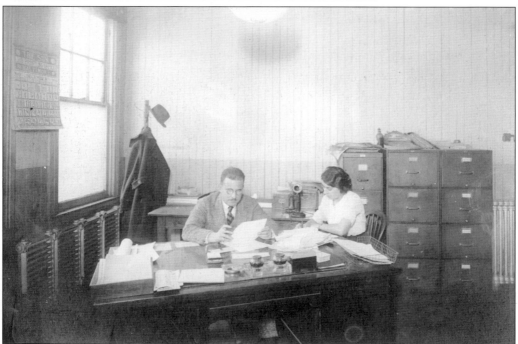

The secretary at the right is Rose Noland. The man at the left is unidentified. This photograph was snapped in the offices of the main company store in December 1922. (Courtesy Dundalk–Patapsco Neck Historical Society Museum.)

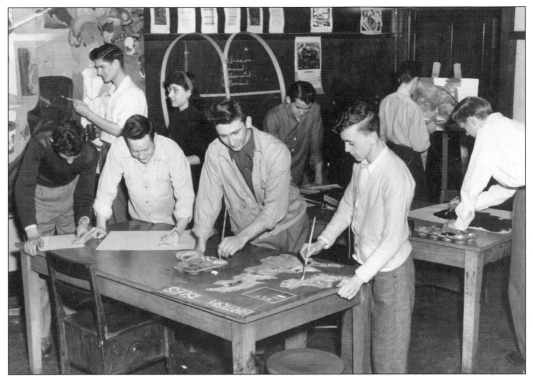

Here a group of students takes an art class at Sparrows Point High School. The image is from 1948. (Courtesy Sparrows Point High School Heritage Center.)

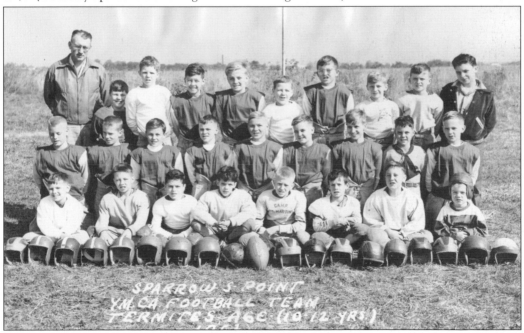

The Termites, a group of 10–12-year-olds, posed for this team picture in 1952. They were one of several football teams fielded by the Sparrows Point YMCA. (Courtesy Dundalk–Patapsco Neck Historical Society Museum.)

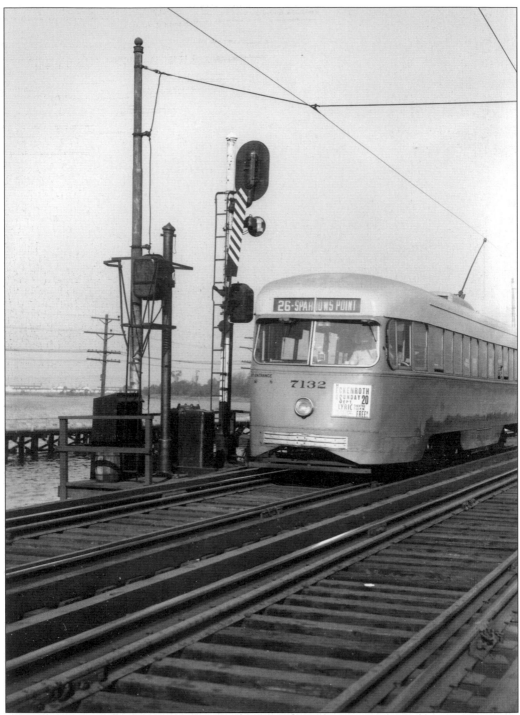

The No. 26 streetcar is photographed streaking across the Bear Creek Bridge toward Sparrows Point. As these were not as flexible as the old wooden Brill cars, a motorman once popped nine windows out by taking a curve too fast on Dundalk Avenue. Streetcar service to Sparrows Point ended in 1958—55 years after it began. (From the author's collection.)

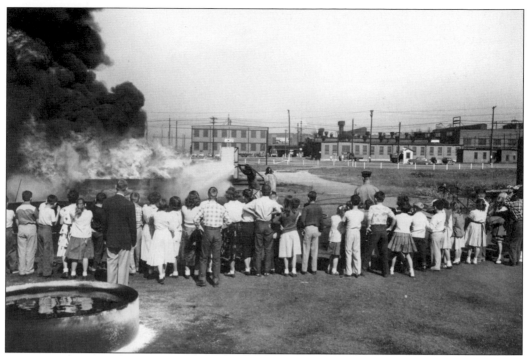

First aid and fire prevention demonstrations were serious matters in a steel-making town. Here schoolchildren watch as firemen douse flames during a demonstration on October 11, 1954. (Courtesy Dundalk–Patapsco Neck Historical Society Museum.)

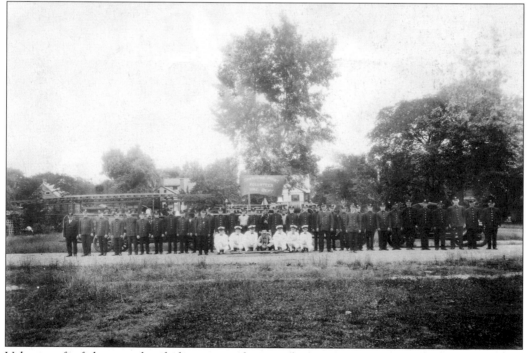

Volunteer firefighters and ambulance attendants took time out to pose for this photograph on June 13, 1930. (Courtesy Dundalk–Patapsco Neck Historical Society Museum.)

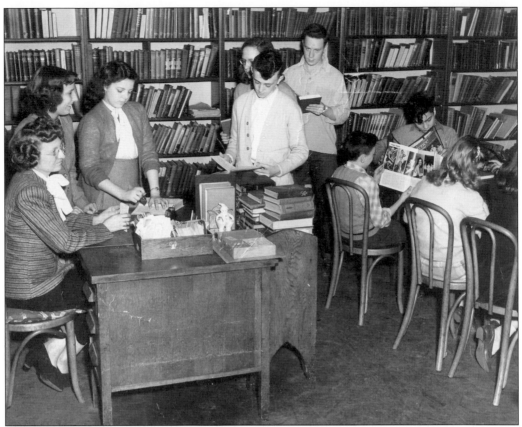

This time, the camera caught students at work in the Sparrows Point High School library in 1948. The librarian was Mrs. Cicone. (Courtesy Sparrows Point High School Heritage Center.)

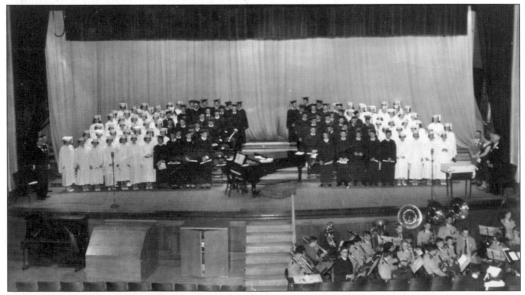

Here's the Sparrows Point High class of 1956. This was the last group to graduate from the old school. (Courtesy Sparrows Point High School Heritage Center.)

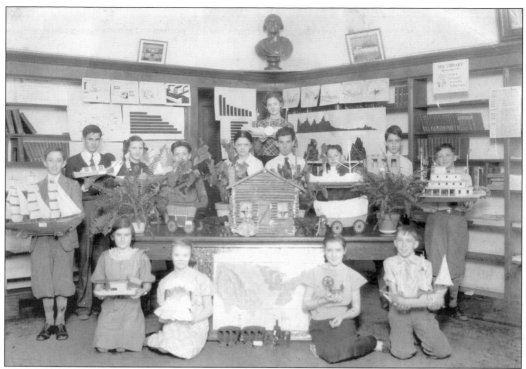

In 1934, these seventh-grade history students pose with their impressive creations for a project titled "The Westward Movement and the Industrial Revolution." The photograph was shot in the old Sparrows Point High library. (Courtesy Sparrows Point High School Heritage Center.)

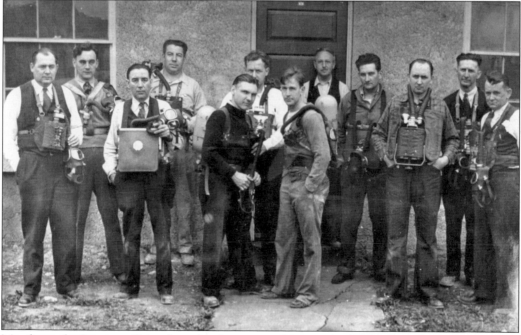

Members of a Sparrows Point fire school training class pose with their breathing apparatus in 1946. (Courtesy Dundalk–Patapsco Neck Historical Society Museum.)

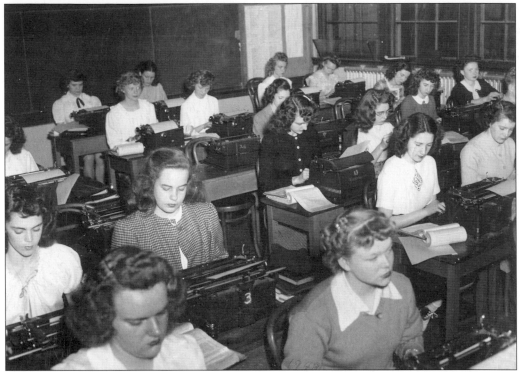

We're back in the classroom at SPHS in 1948—this time in a typing class. Barely visible at the far right was a lone male student. (Courtesy Sparrows Point High School Heritage Center.)

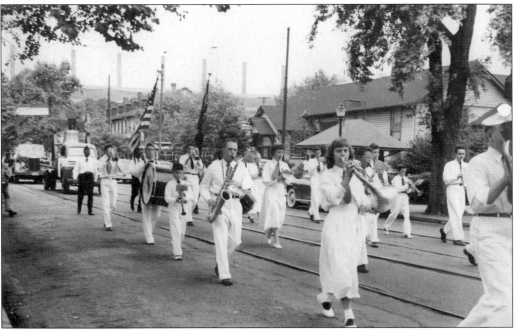

The high school band was on the march during the 1950 Independence Day parade. Officially the event was called the Liberty Bell Parade, part of a savings bond drive. (Courtesy Dundalk–Patapsco Neck Historical Society Museum.)

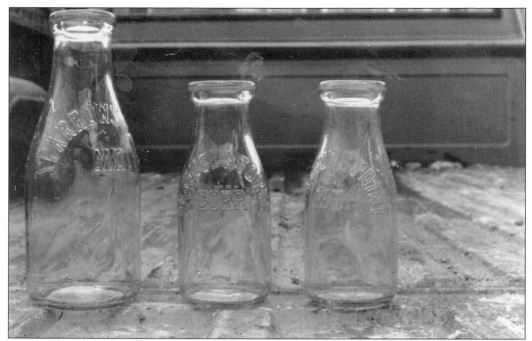

Service Store milk bottles from the Sparrows Point dairy were common sights for decades on the doorsteps of many homes at the Point. They are considered collector's items today. (Courtesy Dundalk–Patapsco Neck Historical Society Museum.)

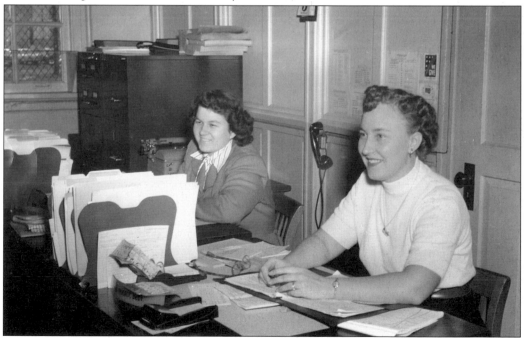

If a Pointer misbehaved and was sent to the principal's office, chances are he or she would encounter secretaries Dot Deale (left) or Barbara Friedly first. Deale was also a graduate of SPHS. This photograph was taken November 9, 1953. (Courtesy Sparrows Point High School Heritage Center.)

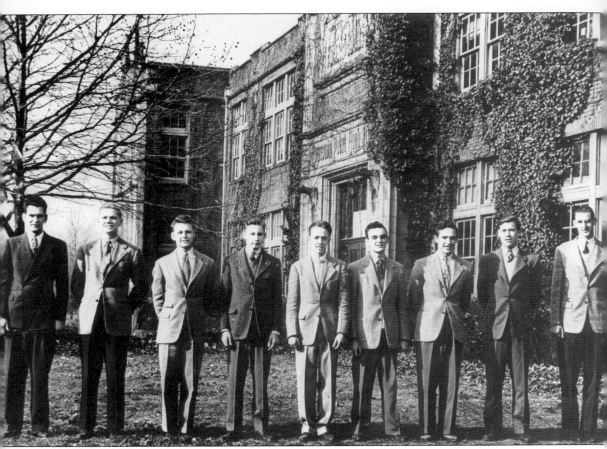

These nine Sparrow Point High seniors were permitted to graduate early in 1944 so they could join the armed forces. They doubled up on their studies and completed their schooling in January as opposed to June. From left to right, they are William Wortman, John Wellinger, David Welhelm, Bill Strickler, Robert Newsom, James Dolan, Carl Tippett, Allen Clinedinst, and Joseph Pika. Less than five months after this picture was taken, Welhelm lost his life during the D-Day invasion of France on June 6, 1944. In all, a total of 105 Pointers were killed or reported missing in action during World War II. (Courtesy Dundalk–Patapsco Neck Historical Society Museum.)

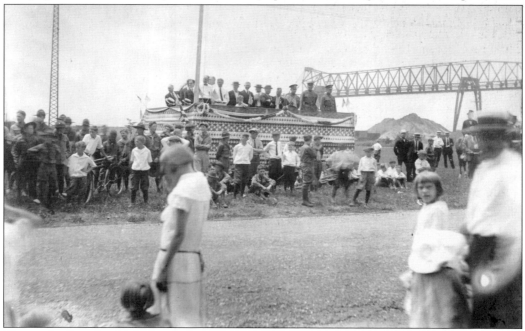

Dorothy MacLyman's report card from September 1916 through 1918 showed a great many Es. At that time, a grade of E meant exceptional. (Courtesy Sparrows Point High School Heritage Center.)

This is the Fourth of July parade reviewing stand on B Street in the late 1920s. The ore piers can be seen in the background to the right. (Courtesy Dundalk–Patapsco Neck Historical Society Museum.)

This house on E Street was all decked out for the Fourth of July. To this day, many former Pointers consider Independence Day second only to Christmas in terms of important holidays. This undated photograph is believed to be from the 1930s or 1940s. (Courtesy Dundalk–Patapsco Neck Historical Society Museum.)

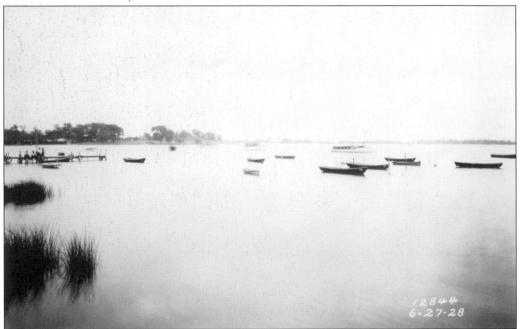

Long obscured by industry is the natural beauty of the waterfront surrounding Sparrows Point. This photograph, along Bear Creek, was taken June 27, 1928. (Courtesy Dundalk–Patapsco Neck Historical Society Museum.)

Five

THE END

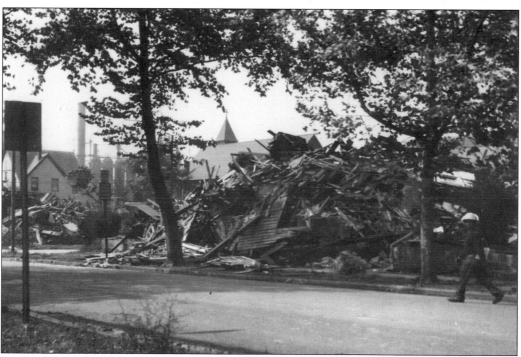

By the early 1970s, Bethlehem's consumption of the town they created was almost complete, this time to make room for the "L" furnace. This photograph, from 1972, shows Seventh Street between E and F. St. Luke's Church can be seen in the background. (Courtesy Dundalk–Patapsco Neck Historical Society Museum.)

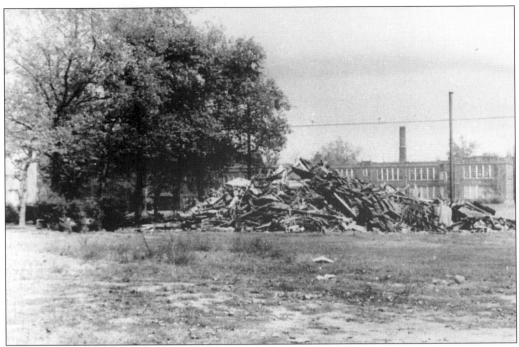

This pile of rubble is all that remained of one of the "white elephants" when this early 1970s photograph was shot. The old Sparrows Point High School building is in the background. (Courtesy Dundalk–Patapsco Neck Historical Society Museum.)

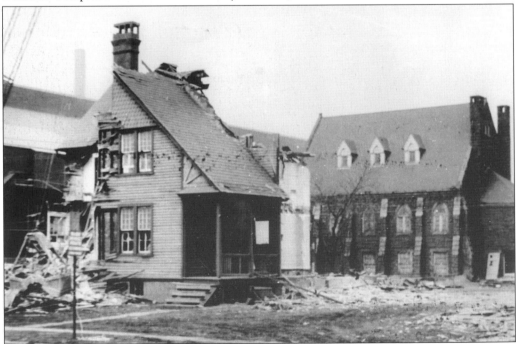

A home on B Street and the church behind it were in the process of being destroyed when this photograph was taken in 1972. (Courtesy Dundalk–Patapsco Neck Historical Society Museum.)

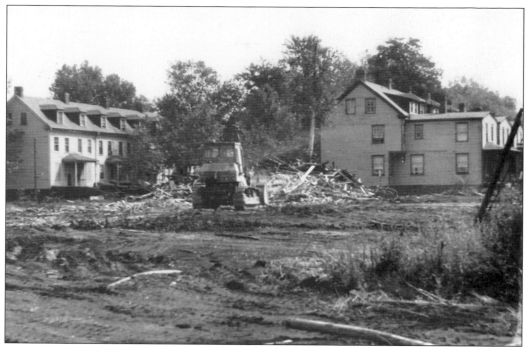

The bulldozer was at work at Sixth and E Streets in this image from 1972. Bethlehem Steel had to survive, and the town was dispensable. (Courtesy Dundalk–Patapsco Neck Historical Society Museum.)

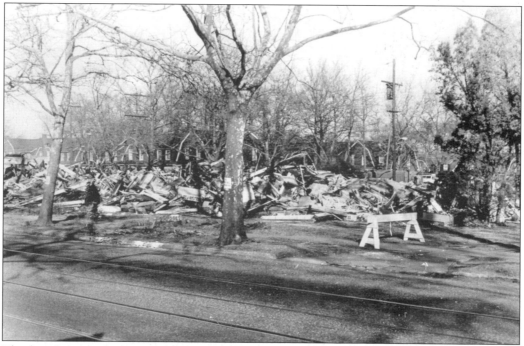

The demolition work continued at a rapid pace in the early 1970s, including here on D Street. Once called "the cleanest and greenest steel mill town in the USA," Sparrows Point was fast approaching the end of its time. (Courtesy Dundalk–Patapsco Neck Historical Society Museum.)

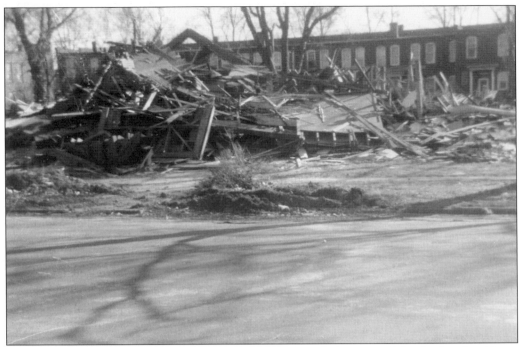

This shot was taken behind H Street, also in 1972. Meanwhile, many of the displaced residents reluctantly found new homes in Dundalk and Edgemere. (Courtesy Dundalk–Patapsco Neck Historical Society Museum.)

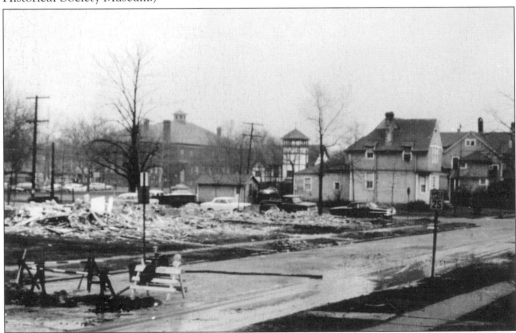

St. John's Evangelical Lutheran Church is still visible—still intact—in the background of this 1971 photograph. The congregation had started building its new sanctuary in Edgemere a year earlier. St. John's fell to the wreckers on December 28, 1971. (Courtesy Dundalk–Patapsco Neck Historical Society Museum.)

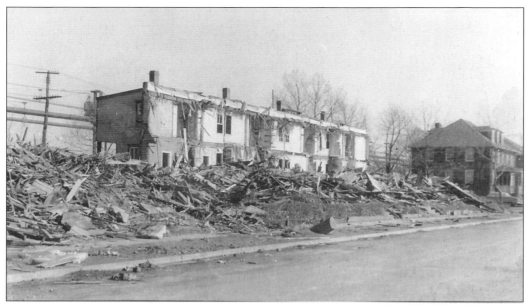

This block, at Fourth and F, came down in 1950. That decade saw Bethlehem Steel's employment numbers rise to an all-time high of 33,000 at the Point. (Courtesy Dundalk–Patapsco Neck Historical Society Museum.)

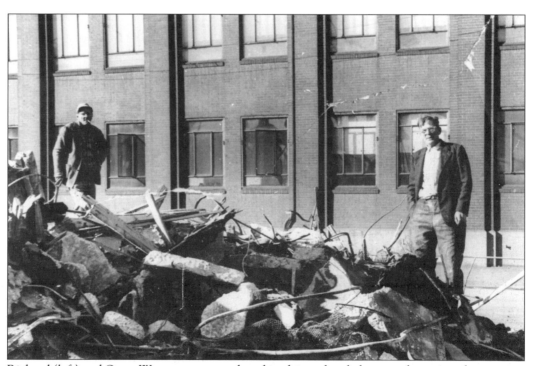

Richard (left) and Oscar Wortman were on hand in this undated photograph to view the remains of the No. 1 Clock House when it came down. This was not a time for obsolescence or sentiment. (Courtesy Dundalk–Patapsco Neck Historical Society Museum.)

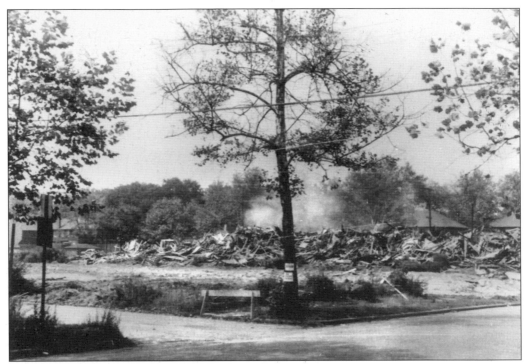

The bungalows were also demolished in 1972. The new furnace would wait for nothing and no one if Bethlehem was to survive. (Courtesy Dundalk–Patapsco Neck Historical Society Museum.)

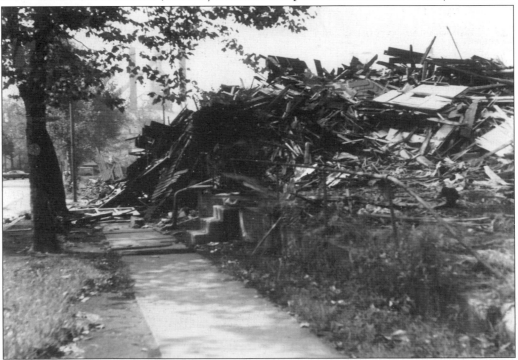

D Street began to look like a landfill by the time this photograph was taken in 1972. (Courtesy Dundalk–Patapsco Neck Historical Society Museum.)

Here is one last look at D Street in 1972. In the end, it was hard to image anything had ever been there. Scavengers and souvenir hunters rooted through the debris looking for keepsakes, only to be chased away by police. And like the town they created, Bethlehem Steel itself would disappear 30 years later. (Courtesy Dundalk–Patapsco Neck Historical Society Museum.)

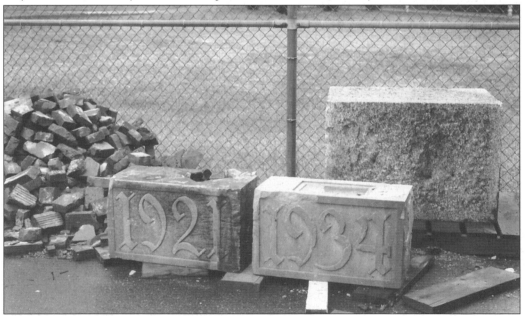

In 1976, a group of farsighted SPHS students and teachers salvaged bricks and the cornerstones from their old school as it fell to the wrecker's ball. These cornerstones can be found today at the entrance of the current Sparrows Point High School. (Courtesy Sparrows Point High School Heritage Center.)

ACROSS AMERICA, PEOPLE ARE DISCOVERING SOMETHING WONDERFUL. *THEIR HERITAGE.*

Arcadia Publishing is the leading local history publisher in the United States. With more than 3,000 titles in print and hundreds of new titles released every year, Arcadia has extensive specialized experience chronicling the history of communities and celebrating America's hidden stories, bringing to life the people, places, and events from the past. To discover the history of other communities across the nation, please visit:

www.arcadiapublishing.com

Customized search tools allow you to find regional history books about the town where you grew up, the cities where your friends and family live, the town where your parents met, or even that retirement spot you've been dreaming about.